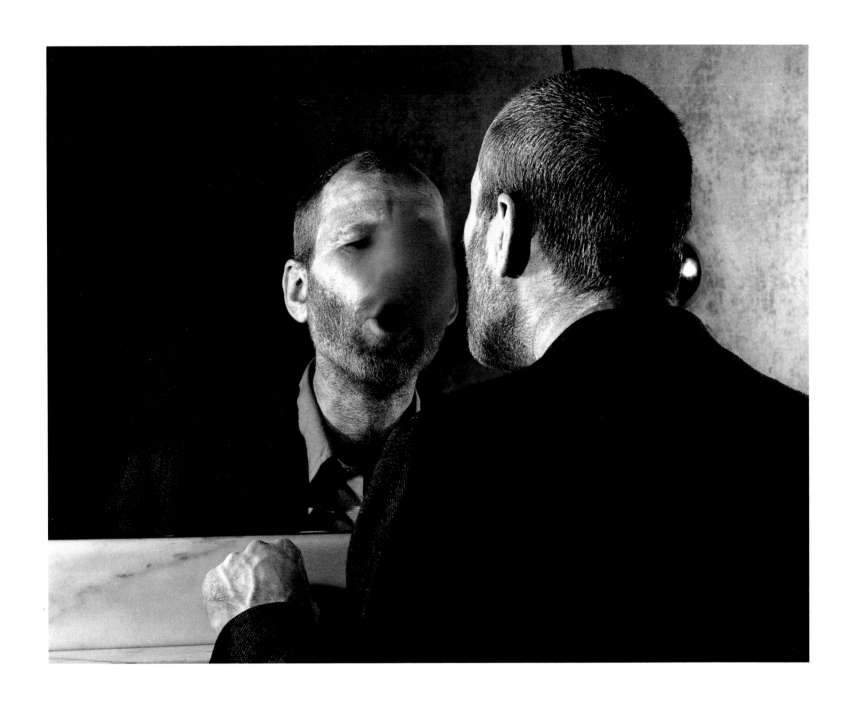

DIETER APPELT

Sylvia Wolf
with an essay by Wieland Schmied

The Art Institute of Chicago
and Ars Nicolai

Dieter Appelt was published in conjunction
with the exhibition of the same title, organized by
The Art Institute of Chicago.
This book and the exhibition it accompanied were
made possible by the support of the Lannan Foundation,
Los Angeles.

The Art Institute of Chicago
November 19, 1994–January 8, 1995

Musée du Québec
March 1–May 28, 1995

Guggenheim Museum SoHo
August 15–November 5, 1995

Contemporary Art Center, New Orleans
December 2, 1995–January 21, 1996

Rencontres Internationales de la Photographie, Arles
March 16–May 27, 1996

Staatliche Museen zu Berlin, Preußischer Kulturbesitz,
Kunstbibliothek
October 15–November 28, 1996

Transportation was provided by Lufthansa German
Airlines and the Institut für Auslandsbeziehungen,
Stuttgart.

Installation photograph of *Tableau Space* (plate 34)
by Yves Gallois.

Copublished by The Art Institute of Chicago,
111 South Michigan Avenue, Chicago, Illinois, 60603-6110,
and by Ars Nicolai, Neuenburger Strasse 17, D-10969
Berlin, Germany.

Distributed in the United States by
D.A.P./Distributed Art Publishers
636 Broadway, 12th Floor, New York, N.Y. 10012
Tel: (212) 473-5119 Fax: (212) 673-2887.

Edited by Robert V. Sharp,
Associate Director of Publications
Production supervised by Katherine Houck Fredrickson,
Associate Director of Publications—Production
Production assistance from Manine Rosa Golden
Designed by Sam Silvio, Chicago
Type composition by Paul Baker Typography, Inc.,
Chicago
Printed and bound in Germany

Library of Congress Cataloging-in-Publication Data

Wolf, Sylvia.
 Dieter Appelt / Sylvia Wolf; with an essay by Wieland
 Schmied.
 p. cm.
 Includes bibliographical references and index.
 ISBN 0-86559-132-6
 1. Photography, Artistic—Exhibitions. 2. Appelt,
Dieter, 1935– —Exhibitions. I. Appelt, Dieter,
1935– . II. Schmied, Wieland, 1929– . III. Title.
TR647.A66 1994
779'.092—dc20 94-28041

Front and back covers:
Die Befreiung der Finger (Liberation of the Fingers), from
Erinnerungsspur (Memory's Trace), 1977–79 (cat. no. 30)

Frontispiece:
*Der Fleck auf dem Spiegel, den der Atemhauch schafft (The
Mark on the Mirror Breathing Makes)*, 1977 (cat. no. 36)

Contents

Acknowledgments

I first saw Dieter Appelt's work in a thin, cream-colored paperback book that a friend had randomly pulled off a shelf in the massive bookstore on the ground floor of the Centre Georges Pompidou in Paris. The book was small and bore no image on the cover, only Appelt's name. As I stood there turning page after page, I quickly lost track of time and forgot how sore my feet were from a long day of walking. I was transfixed by Appelt's art. When I look back on the happenstance of finding that discrete little book with the skinny black type among the dozens of bolder titles, I am reminded that this project was charmed from the start.

First, there was the electric energy of the work itself. Then came three years of intense collaboration with Dieter Appelt as we charted the first account of his life and art. At an early and crucial point in the evolution of this project, the Lannan Foundation of Los Angeles committed their support to this publication of Appelt's work, the accompanying exhibition, and its tour. For their enthusiastic response to Appelt's art, I am deeply indebted to Lisa Lyons, Director of Art Programs, and her colleagues at the Lannan Foundation. Thanks go to Lufthansa German Airlines, in particular to Bob Armajani, Marketing Manager USA Midwest, for providing transportation for research and shipment of the artworks. An important contribution to the transportation of Appelt's work was also provided by the Institut für Auslandsbeziehungen, Stuttgart, thanks to the efforts of Anneliese Kluge and Alexander Tolnay. Hans-Georg Knopp, Director of the Goethe-Institut, Chicago, has been an advocate of the Appelt project from the beginning. I offer sincere thanks to him and to the Goethe-Institut for bringing Appelt to Chicago as visiting artist to The School of the Art Institute.

The Dieter Appelt exhibition and publication were enhanced by the efforts of many individuals at The Art Institute of Chicago. I am grateful to James N. Wood, Director and President, and to David Travis, Curator of Photography, for sharing my enthusiasm for Appelt's work from the very beginning. Several members of the Art Institute's staff have been instrumental in bringing this exhibition and monograph to fruition. I am particularly grateful to Dorothy Schroeder, Assistant Director for Budgets and Exhibitions; Karin Victoria, Director of Government Relations; Anna Brown, Grants Assistant; Greg Cameron, Director of Exhibition and Special Project Funding; Mary Solt, Executive Director of Museum Registration; Mary Mulhern, Associate Registrar; and Madeleine Grynsztejn, Associate Curator of Twentieth-Century Painting and Sculpture. In addition, I am indebted to members of the Art Institute's Department of Photography, past and present, who were a constant base of support from the first days of the project to the

opening of the show: Doug Severson, Colin Westerbeck, Karen Renteria, James Iska, Kristin Nagel, Russ Harris, and Susan Bialk.

This monograph was produced by The Art Institute of Chicago's Publications Department under the direction of Robert V. Sharp, Associate Director of Publications, and Katherine Houck Fredrickson, Associate Director of Publications-Production. I am also grateful for the production assistance of Manine Rosa Golden. Sincere thanks go to Wieland Schmied for enhancing this study of Appelt's art by contributing a text to the publication. Sam Silvio deserves a special note of appreciation for presenting Appelt's photographs with grace, elegance, and sensitivity in his design of the book. Grateful appreciation is due to the staff of Ars Nicolai, Berlin, and to Dieter Kirchner for his commitment to bringing Appelt's work to life on these pages. Thanks also go to D.A.P./ Distributed Art Publishers, in particular Sharon Gallagher, for distributing the book throughout North America.

I thank my colleagues at the participating venues in the exhibition tour: Lisa Dennison and Jennifer Blessing at the Solomon R. Guggenheim Museum, New York; Lew Thomas, Visual Arts Curator of the Contemporary Arts Center, New Orleans; Didier Prioul, Claude Thibault, and Michelle Grandbois at the Musée du Québec; and Wolf Dieter Dube and Bernd Evers of the Staatliche Museen zu Berlin, Preußischer Kulturbesitz, Kunstbibliothek. For their assistance with the exhibition, I would like to thank Priska Pasquer at Galerie Rudolf Kicken, Cologne; Wolfgang Günther at Galerie Limmer, Freiburg; and Gitta Lutze at Galerie Springer, Berlin. For generously agreeing to loan works to the exhibition, I am grateful to these individuals and institutions: Hanna Appelt; Berlinische Galerie, Berlin; Blondeau Fine Art Services, Geneva; Henry Buhl, New York; Fonds Regional d'Art Contemporain, Provence-Alpes-Côtes d'Azur; Manfred and Hanna Heiting, Amsterdam; Jürgen Hermeyer, Munich; Galerie Rudolf Kicken, Cologne; Galerie Limmer, Freiburg; Museum of Modern Art, New York; Neue Galerie der Stadt Linz; Ursula and Peter Raue, Berlin; Sander Gallery, New York; Elisabeth-Schneider-Stiftung, Freiburg; and Joshua Smith, Washington, D.C.

During my research on Appelt's life and art, several individuals were eager to help and generous with their knowledge and expertise. I extend sincere thanks to Betty Buccheri, Assistant Conductor of the Lyric Opera, Chicago, and Diana Davis and Bill Mason for our conversations about twelve-tone music and opera. At Northwestern University, Evanston, Illinois, I am grateful to Christine Froula, Ezra Pound scholar and Professor of English; and to George Bond, Professor and Chairman of the Department of Religion. At The Art Institute of Chicago, I acknowledge with gratitude Elinor Pearlstein, Associate Curator of Chinese Art, for contributing information about the Chinese written and spoken language, and Maureen Lasko, Senior Reference Librarian, for proving to be, once again, a researcher's best friend and guardian angel.

At the core of the Appelt project is a team of extraordinary people, without whom this project would have been greatly diminished. Rudolf Kicken's unfailing support, long hours translating, and deep love of photography and of Dieter Appelt's art is forever appreciated. I would like to express my special thanks to Stephanie Lipscomb for compiling Appelt's biographical material with determination and skill, to David Hartt for becoming a first-rate researcher, and to Birgit Rathsmann, whose gifts with translation and unparalleled commitment made her an essential part of the project. Several others, either in conversation or with research, provided vital support in the realization of this book and the accompanying exhibition. I owe a particular debt of gratitude to Elisa Lapine, Richard Bolton, and David Osborne. Many thanks also go to Jodie Ireland, Olivia Gonzalez, Gwen Bucken, Celia Greiner, Eva-Maria Schuchardt, Tatyana Filienger, Anna K. Donohoe, and Annabel Hünermann. I am especially indebted to Jed Fielding for pulling Appelt's book off the shelf in Paris five years ago and for providing constant support and encouragement ever since. His perceptive reading of the manuscript and his sharp observations at every stage of this project helped me clarify my thoughts.

Finally, I would like to express my appreciation to Dieter Appelt. A study such as this one, which surveys an artist's personal and creative history for the first time, is made possible only with the openness and commitment to discovery of the artist himself. At each point in the project, Appelt gave our work together the same energy and determination he applies to all of his art. For over three years, both Dieter and Hanna Appelt were exceedingly generous with their time, hospitality, and memories. For this, my gratitude is deep and long-lasting.

Sylvia Wolf
Associate Curator of Photography
The Art Institute of Chicago

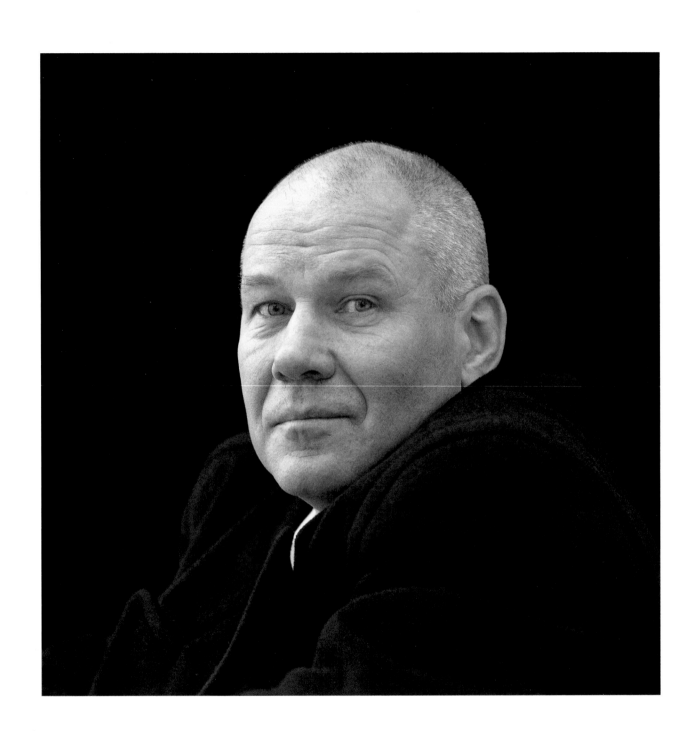

DIETER APPELT

by Sylvia Wolf

Dieter Appelt once told me about the aftermath of a battle that took place during World War II. In April 1945, one month before the end of the war, the farm Appelt's family lived on southwest of Berlin was taken over as a military outpost by the S.S., and his family was evacuated to a city nearby. The farm sat next to a bridge, over which the main road to Berlin crossed the Mulde River. As German forces retreated, the American army surprised them from the west, the Russian army moved in from the east, and a quick, intense battle took place. When the Germans were overtaken, several soldiers jumped from the bridge to escape. Some were shot in the water. Two weeks later, Appelt's family returned to their farm, and in the days and weeks that followed, ten-year-old Dieter stumbled upon guns, shells, and dead soldiers in the fields and marsh grasses behind his house.

Thousands of Europeans faced similar sights. The discovery of decomposing bodies, pungent with odor and caked with dirt, was not an experience unique to Appelt. But in conversation with him over the years, I have come to realize that this experience solidified Appelt's anti-fascist beliefs and gave him emotional strength. Out of that strength came an inquisitiveness and a resourcefulness that he has made good use of in his art. Now, at the age of fifty-nine, Dieter Appelt is one of the most prodigious and complex of Germany's photographic artists. His work runs the gamut of conflicting forces—from influences rooted in history, to attempts to transcend that history. His creativity draws on science, poetry, and mythology, but most of all, it is charged with energy from his past and with the curiosity he developed as a youth. In his story, therefore, lies the essence of his art.

Dieter Appelt, 1992
Photo © 1992 by Mariana
Cook, New York

Dieter Appelt was born on March 3, 1935, to a Lutheran couple in Niemegk, Germany, a small village roughly one hundred miles southwest of Berlin. Soon after his birth, the Appelts moved to Mühlenbeck, a tiny town near Dessau, where his maternal grandfather owned a farm and the roadside restaurant "Gasthof zum Muldental." Dieter's mother, Frieda, managed the restaurant. His father, Erich, was a painter and interior designer, as well as an amateur photographer who made his own cameras. Dieter was too young to have shared his father's interests before Erich Appelt died in the army of a kidney infection in 1939. But as Dieter grew older, he developed many of his father's passions for literature and photography.[1]

Dieter was four and a half years old when England went to war with Germany in response to German aggression in Eastern Europe, and World War II began. What few memories he has of the war are of seeing and hearing Dessau being bombed at night, and of the aftermath of the battle that was fought near his family's grounds. "The war took place in front of our house," Appelt says today, with the same disbelief that might be voiced by a child who suddenly finds the distant realm of world events has landed on his doorstep.[2]

By the time the war ended, Dieter had become a serious, fiercely curious child—a loner. While other boys and girls his age read adventure stories about the American West by the German novelist Karl May, Dieter read Kafka, Tolstoy, and classic novels from his father's collection of books.[3] He had few regular playmates, and more often than not, he spent his time after school drawing, playing with the Great Danes that were the family's pets, or reading while he floated in a small rowboat on the river behind the farm. As a child, Dieter developed an active imagination, one that made him particularly receptive to the films that were brought to town once a month by a traveling film troupe both during and after the war. The films were screened in the assembly hall of his family's restaurant, and Dieter quickly learned to master the projector. He was fascinated with the mechanics and the fantasy of film, with the movement of the reels, and with how the images came to life on the screen. Whether it was a love story or a propaganda picture, Dieter's eyes were riveted to the halting, flickering images that transformed the assembly hall into a living theater, animated by light and shadow.

As a teenager, Dieter developed an interest in another form of camera-generated imagery. With his father's photographic cameras, among them a five-by-seven-inch model from the 1930s, he made figure studies and landscapes. (He remembers never having had instruction in photography and he now thinks he must have learned to make contact prints of his negatives on his own.) Appelt adds that he might have pursued photography as a profession earlier than he did if one of his high school teachers had not noticed that he had a gift for rhythm and melody, and encouraged him to consider a career in music. Though he had been raised to the sound of beer-drinking songs, over the next two years Dieter took to a more serious form of music. He learned to play piano, recorder, and guitar, and in 1954 he auditioned for and was accepted into the Mendelssohn Bartholdy

Akademie der Musik, Leipzig. It was there that he developed a rich baritone singing voice and was first introduced to modern art.

Appelt's voice softens when he talks about his singing teacher at the Leipzig academy, Rita Meinl-Weise, a Russian soprano popular in Germany in the 1940s and a former student of the Russian Constructivist artist Kasimir Malevich. When he first met Meinl-Weise, Appelt was an earnest, handsome young man nearing twenty (fig. 1). She was a wise and exuberant woman, aged forty-nine. Enchanted by each other, the two became fast friends. Meinl-Weise owned a large collection of books and works on paper by Impressionist, Fauve, and Russian Constructivist artists, and Appelt spent hours looking through them, amazed by their energy and emotion. He found a musical counterpart for this visual stimulus in the twelve-tone works of the twentieth-century Viennese composer Arnold Schoenberg and his followers Anton Webern and Alban Berg.[4] Much like the art in Meinl-Weise's collection, twelve-tone music challenges academic structure and traditional form. It is rigorous, dense, and deadly serious. Because no single tone dominates, twelve-tone music has infinite compositional possibilities, unlike the hierarchical character of Western music based on octaves. The form of the infinite appealed to Appelt, as did twelve-tone music's modern, expressive sound.

When Appelt was twenty-two, he met and soon married a voice student from Magdeburg. Hanna Appelt shared her husband's curiosity about art and the avant-garde. Dieter valued her honesty: over time, she has remained his best critic and his most ardent supporter. Shortly after they were married, Dieter and Hanna moved to Stendal to pursue a joint internship. Then, in October 1959, they left the German Democratic Republic and settled in West Berlin.[5] To finish his studies, which had been interrupted by the move,

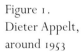

Figure 1.
Dieter Appelt,
around 1953

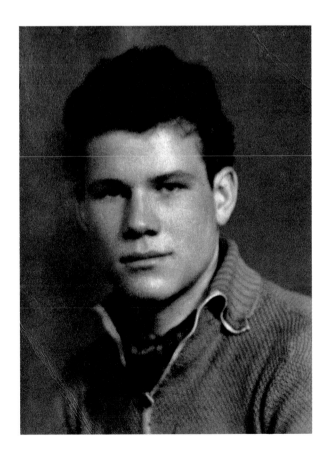

Appelt enrolled at the Berlin Hochschule der Musik (Academy of Music), located directly across the street from the Hochschule für bildende Künste (Academy of Fine Arts), where Heinz Hajek-Halke, one of Germany's masters of experimental photography, was professor. For over thirty years, Hajek-Halke had practiced photomontage and double-exposure photography. He had become a specialist in macro-photography and in graphic and chemical manipulation of photographic film. Though he was never part of the German Bauhaus, Hajek-Halke has acknowledged its innovative spirit as an influence and, like the Bauhäuslers, he emphasized the merging of craft and aesthetics: "Apart from one's own talent, success depends on mastery of technical methods, on the indispensable sense of form and composition, on patience and endurance."[6]

Curious about what he heard of Hajek-Halke, Appelt arranged a meeting. Though he no longer remembers what pictures he brought with him, the teacher must have seen potential, for he encouraged Appelt to join his class. With Hajek-Halke, Appelt became adept at the technical aspects of photography. He studied collodion printing and experimented with merging positive and negative images to make a single picture. But most of all, he learned how to see. "When I met Hajek-Halke, he was doing photograms and was looking for objects to make them with. Berlin was still a city in ruins, so we would go out together and search through the rubble. Hajek-Halke said to me, 'Every time we look for me, we'll look for you. I'll show you how and what to photograph.'"[7]

Under Hajek-Halke's tutelage, Appelt could have been satisfied making images that were clever and adroit in composition and design. But much as when he chose Schoenberg and Berg over a more conventional form of music, Appelt now opted for meaning over the simple execution of class assignments. Among his first photographs is one taken in Hitler's bunker, fifty feet below the German Reichskanzlei (Chancellery), where Hitler spent the last weeks of the war and the final hours of his life. In 1959 and 1960, the area was closed to the public, and to get in, he had to climb through an opening in the ceiling. In a flooded, musty room, littered with plaster and bricks, Appelt made a moody picture of an armchair with shredded upholstery (fig. 2). Even without the title *Führerbunker*, it is a haunting image of destruction and decay. In context, the chair reads as a metaphor for the Germany Hitler left behind: stripped, unstuffed, exposed.

Appelt continued to photograph in abandoned buildings and to study art and art history after he passed his music exam in 1961 and was hired to sing for Berlin's opera company, the Deutsche Oper Berlin. That same year, the Soviet-backed German Democratic Republic closed the borders between East and West Berlin and constructed the Berlin Wall. Over the next two decades, Berliners responded to communist isolation with an increase of artistic activity, public demonstrations, and an international exchange of artists and ideas.[8] During this time, Appelt attended exhibitions, happenings, and iconoclastic performances by Fluxus artists, many of which were conducted in protest of political events.

Figure 2.
Führerbunker, 1959—60

Though the Berlin Wall was a mobilizing factor, for artists in particular, it disrupted the slow process Germans were going through of redefining their personal and global identity in the postwar world. When the wall went up, the German people had not yet come to grips with the trauma they had caused and observed during the war. Now, the enemy in their midst served as a distraction. The German artist and political activist Joseph Beuys knew this, and Appelt watched him intently. Appelt was deeply affected by documentary photographs of Beuys's performances, or *aktion*s as he called them, especially one in Aachen during which a young man punched Beuys in the face and the artist made the aggressive act a part of the performance.[9] With the blood running down his mouth and chin, Beuys lifted a crucifix and remained motionless, his other hand extended in greeting. Appelt was fascinated with how he transformed a violent act into a symbolic event: Beuys stood before the audience as a martyr, absorbing the anger and violence of all people.

Appelt was intensely affected by Beuys and by others he admired, and yet he never subscribed to any of the movements or groups formed in Berlin in the sixties. After leaving the Hochschule für bildende Künste in 1964, he continued to follow Hajek-Halke's mandate to experiment. He drew and painted, and he made sculptures, photographs, and etchings. In search of an expression that could be identified as his own, Appelt was particularly influenced by artists who had already found theirs. If he saw something that touched him—the quivering forms of Henri Michaux's black-and-white drawings, for example, or the grotesque caricatures etched in nervous line by James Ensor—he would emulate the work until the style became his (fig. 3). Where most of us are content simply to feel emotion when we are affected by art, music, or literature, Appelt *acts* on his emotions—taking what provokes him and making it his own through his art.

Figure 3.
Meine Familie (My Family),
1964
Etching on paper
9.5 x 19 cm

Figure 7.
From *Moorbegehung*
(*Crossing the Moor*), 1977

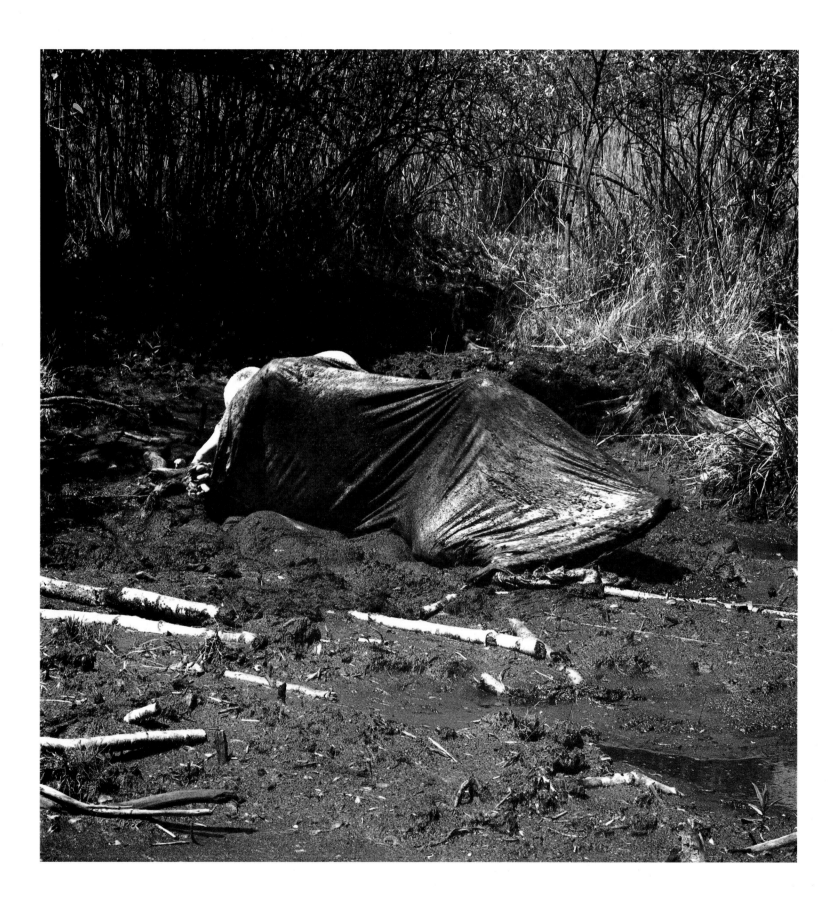

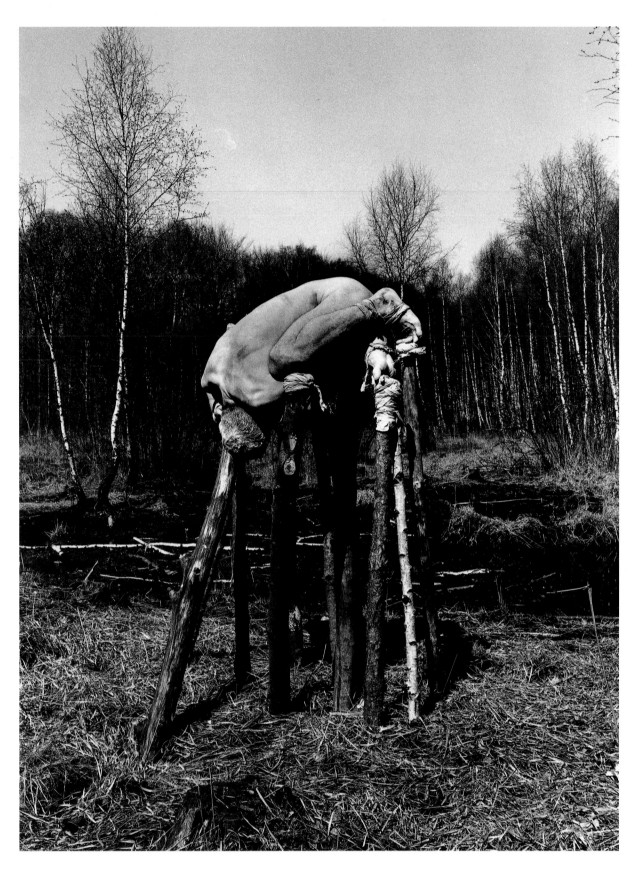

Figure 8.
Ich will mich nicht über die Bäume erheben (I don't want to elevate myself above the trees), from *Moorbegehung (Crossing the Moor)*, 1977

as in Leonardo da Vinci's fifteenth-century Vitruvian figure. Da Vinci's drawing supports his theory that science, geometry, and symmetry evolve from the human form. Appelt's photographs show us that *Augenturm*'s measurements were deduced from *his* form.

Augenturm is part of a complex genealogy of interlocking images Appelt made between 1977 and 1979 called *Erinnerungsspur (Memory's Trace)*. Included in the series are images of his face caked with marble powder, of his hands wrapped in stiff linen bindings, and of a vice gripping a human skull (pls. 10–23). Appelt acknowledges that his childhood memories of dead soldiers contributed to the way these pictures look, but he warns against viewing them as strictly autobiographical, and he is vehemently opposed to any psycho-analytical reading of the work. He feels that the photographs come from a wider range of human experience. When Appelt made these images, he was interested in the idea of the artist as shaman, as spiritual medium, who draws on both personal experiences and things inherited from ancestral memories. He describes many of these pictures as though they were déjà-vu—previously envisioned but never actually experienced—as though they existed in his subconscious and he had acted on some inner order when he made them into art. The ancient feel of his photographs reflects his thinking. The pictures conjure up images of tribal rituals and mythical rights of passage—all of which are ceremonies that are directly linked to the death or well-being of a single member or the group. Appelt's photographs are charged with a similar urgency of purpose.

This period of intense work is punctuated by a single photograph—an unusual form for Appelt, who places most of his pictures in groups or series. *Der Fleck auf dem Spiegel, den der Atemhauch schafft (The Mark on the Mirror Breathing Makes, 1977)* is an image of Appelt, his back to the camera, blowing on a mirror.[16] His reflection is veiled by the condensation of his breath, and the soft diffusion creates a striking contrast with the stubbly texture of the artist's short-cropped beard and hair (pl. 24). Although Appelt uses himself in a large number of his pictures, this may be his only self-portrait, for it shows him at work, giving the intangible a photographic form. There on the looking glass, in the territory between reality and its image, is where Appelt makes his mark.

Appelt was forty-four when he realized that his true creative voice was in photography, and, after eighteen years as a member of the chorus and an occasional soloist for the Deutsche Oper Berlin, he left in 1979 to devote himself full-time to his art.[17] During the next three years he traveled extensively, to France, Mexico, and back to Italy. He had several international exhibitions, and he produced a wide variety of work, often inspired by his travels. On two trips to Mexico, Appelt made a film and a photographic series drawn from the epic story of the life of the Aztec mythological figure Quetzalcóatl.[18] He took pictures of prehistoric granite megaliths in Carnac, France. And he visited the canyon of Oppedette, in the Haute Provence region of France (pls. 25–27). In Oppedette, Appelt photographed himself lying in a fetal position in a natural spring. He built nineteen-foot

Figure 9.
Haus in Oppedette
(House in Oppedette), 1980
Model and gelatin
silver prints

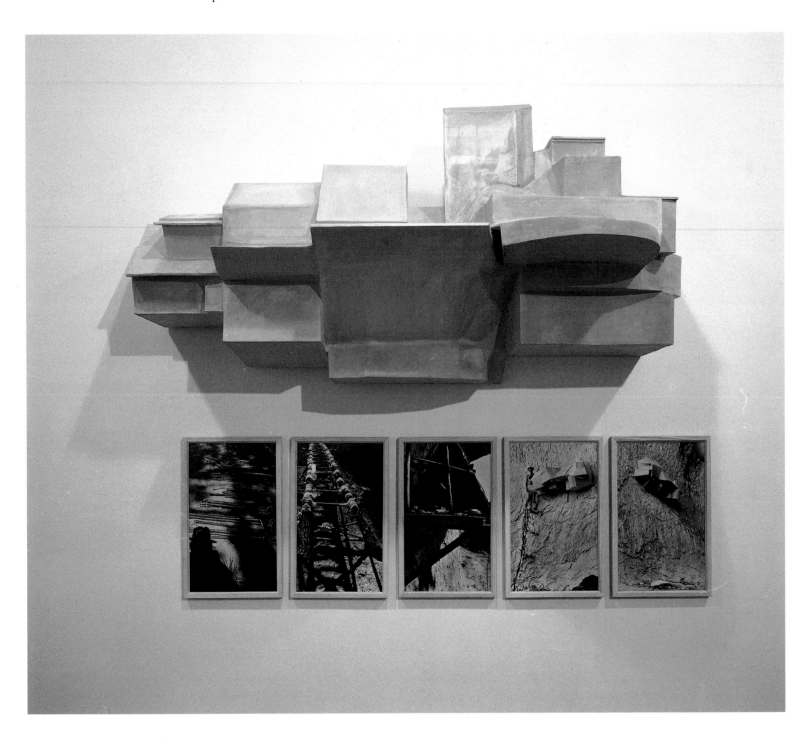

wings to wear in a subterranean cave. Thinking of Native-American Anasazi ruins, he constructed a cliff-dwelling that he mounted on a rock face and left behind to become part of the landscape (fig. 9).[19]

The photographs and film stills Appelt made of Carnac and Mexico are more static, less evocative than his previous pictures. Here, the artist appears uncharacteristically self-conscious (fig. 10). The images serve as documents of the *aktion* he performed at each location more than as photographs that are visually and emotionally convincing in and of themselves. The importance of these pictures, then, lies not in their form, but in their ethnological references and in what they say about Appelt's desire to seek wisdom, insight, and creative ideas in worlds other than his own.

Figure 10.
Film still from *Spur des Quetzalcóatl (Quetzalcóatl's Trace)*, 1981

In 1981, Appelt's travels culminated in another visit to Italy, this time to pay homage to Ezra Pound. An avid enthusiast of Pound's poetry, Appelt went to Venice where Pound had died in 1972 at the age of eighty-seven. He borrowed Pound's coat, scarf, walking stick, and hat from the poet's caretaker, and he took pictures of himself walking where Pound might have walked or reading a newspaper in an outdoor cafe as Pound might have done (fig. 11). He finished the series at Pound's grave, where he carefully folded the poet's belongings and placed them at the gravesite along with his dog-eared copy of Pound's English translation of Confucius.[20] Appelt also took pictures in a room in San Ambrogio, where Pound had lived. One image is of a straight-backed chair, printed in positive and negative to give it a layered effect and to remove it from any direct representation of the site (pl. 28). Appelt's selection of the double-printed, positive-negative form for Pound's chair reflects his understanding of the poet's writing. A proponent of cross-fertilization, Pound used different languages and disparate poetic structure to build a composite experience:

> Bunting and Upward neglected,
> all the resisters blacked out,
> From time's wreckage shored,
> these fragments shored against ruin,
> and the sun 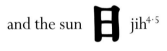 jih[4·5]
> new with the day.[21]

To experience Pound's poetry, we have to suspend our expectations of narrative structure and read lines over and over again until the words become sounds and their meaning dissolves into free-flowing associations. This aspect of Pound's work, its complexity and disorienting composition, appealed to Appelt. Though some critics believe Pound's method signals confusion rather than innovative genius, Appelt finds truth in Pound's opposition of form and flux.[22]

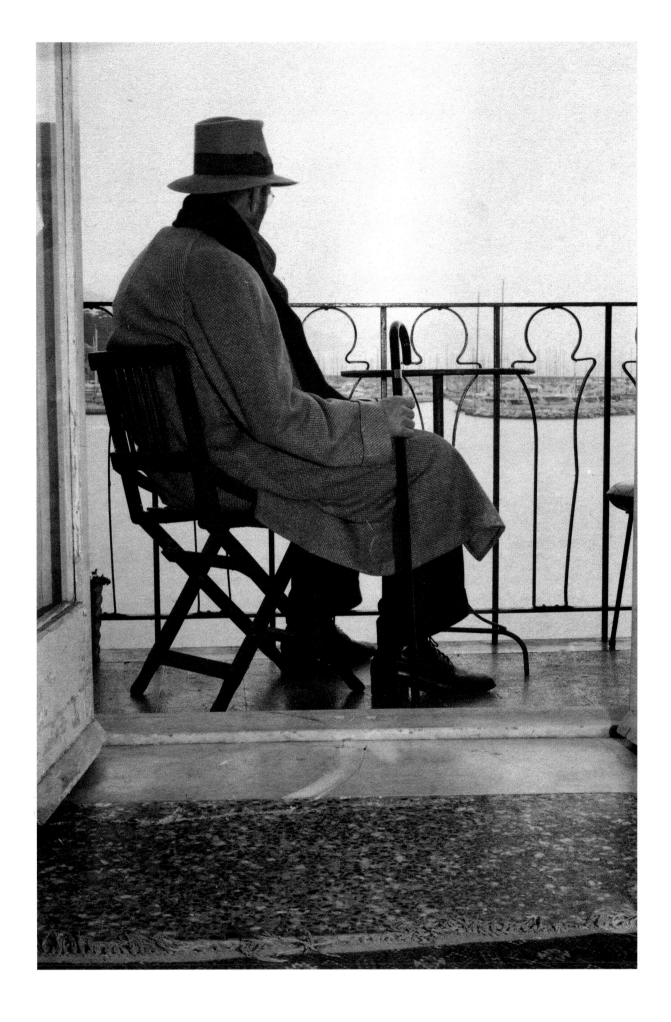

Figure 11.
From the sequence
Ezra Pound, 1981

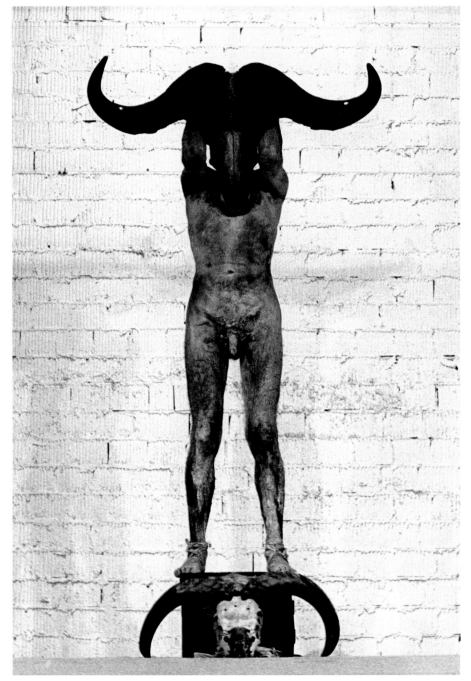

Figure 12.
From the *aktion Die Symmetrie des Schädels (Symmetry of the Skull)*,
January 16, 1977
Galerie Georg Nothelfer, Berlin
Photo by Hanna Appelt

Apart from the situations Appelt enacted for the camera, he also produced several public performances in the 1970s and early 1980s. Appelt cites three in particular as still significant today. The first, titled *Die Symmetrie des Schädels (Symmetry of the Skull*, 1977), was a one-hour event in which Appelt stood nude on a podium draped in white, his body whitened by marble dust and his wrists and ankles wrapped in linen straps.[23] Facing the audience were five animal skulls arranged front to back in ascending size. Slowly, at a ritualistic pace, Appelt lifted and held each skull aloft, one by one, for the audience to see (fig. 12).[24] In the last ten minutes of the event, he hoisted himself up to a pipe he had suspended from the ceiling and he hung by his ankles while the audience of some three hundred people watched in silence. A fit man with a shaved head, a broad face, and chiseled features, Appelt appears in this performance as both a specimen of physical strength and a specter of death.

Another live event, called *Black Box,* was performed several times.[25] For each, a large handmade box was placed in the center of the exhibition space (fig. 13), and photographs from the series *Erinnerungsspur* were hung on surrounding walls. During the performance, Appelt lay immobile for over two hours, eyes closed, in shallow water made

Figure 13.
From the *aktion Black Box*,
July 14, 1979
Hamburger Kunstverein
Photo by Enno Kaufhold

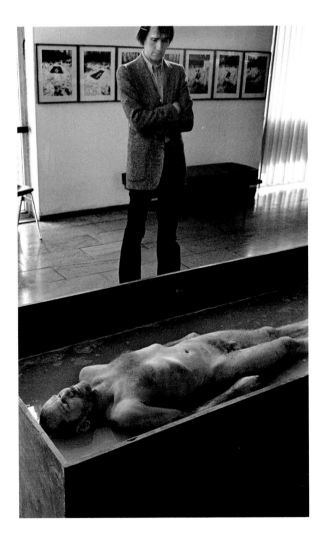

milky by marble powder. No one saw him get in or out of the box and visitors could barely see him breathe. With his ears plugged with wax to prevent water from getting in, he heard nothing but the dull rhythm of visitors' footsteps. Appelt refers to this performance as a long exposure in which he functioned as the subject of an image viewers remembered when they left. Here again, memory turns up as a theme. Moreover, Appelt's body left its impression in a layer of damp clay in the box. Once the *aktion* was over, the sediment settled into the imprint and the water evaporated, leaving a negative image of Appelt's presence for the run of the show.

The third of the three public events was generated from a seventeen-minute film made in 1981. In the film, Appelt pulls a rope that has been glued as a center line from his back, over his head, down the middle of his face, to his chest at an agonizingly slow pace. Titled *Image de la Vie et de la Mort (Image of Life and Death)*, the piece was inspired by a sculpture of the same name Appelt saw at the National Museum of Anthropology, in Mexico City. The left side of the sculpted face is alive and the right side is a skeleton. Here, life and death are two sides of human existence, two halves of a whole. (Another of Appelt's films, *Ganz-Gesicht* [*Whole-Face*], in which a woman's face is multiply-exposed with a skull [fig. 14], is a different offshoot of the Mexican sculpture.)

After *Image de la Vie et de la Mort* was made, Appelt designed a gallery installation in which the film played on a large screen, and the artist—enclosed in a box in the middle of the room—performed from memory the exact same motions in the film. A video camera recorded his actions and played them simultaneously on four monitors situated in the corners of the gallery. As a soundtrack, Appelt used the high-pitched noise cicadas make in the heat of summer. In the context of the imagery, the soundtrack resembled the peeling or ripping of skin, making the installation tough, relentless. Appelt does not show the original film anymore, but a photographic piece he generated from the film has become one of his signature works. The piece represents one second of *Image de la Vie et de la Mort*, a moment when Appelt hollered to Hanna to stop filming. In less than thirty frames, it registers the minute changes in Appelt's face as it goes from repose to a scream (pl. 29).

At the time Appelt's *aktions* were presented, ritualistic public performances in which artists stretched a simple activity over time or subjected their body (or someone else's) to physical pain were not new. Joseph Beuys had been doing such things for more than ten years when Appelt performed his first public event. The Viennese Action Group (led by Otto Mühl, Günter Brus, Hermann Nitsch, and Rudolf Schwarzkogler) elevated the form to an agonizing pitch in the 1960s and 1970s.[26] Like many *aktions* by Beuys and the Viennese Actionists, the body is at the center of Appelt's work. But he rejects any link to the Austrians. "Theirs had too much to do with blood, violence, and nihilism," he says. "My *aktions* were very static, very slow changes, not outbursts."[27] He also asserts the differences between Beuys's intentions and his own. "I am a student of Beuys if you will…but Joseph

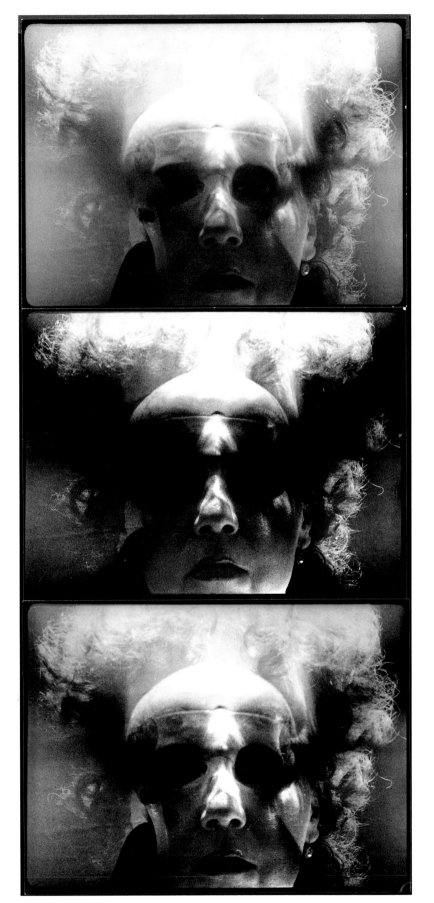

Figure 14.
Film still from 16 mm film,
Ganz-Gesicht (Whole Face),
1982–83

Beuys had a strategy, a social agenda, a utopian vision. I do not."[28]

It is true that Appelt does not, intentionally, make art with a social agenda in mind. But Beuys would take issue with Appelt's separation of his art from social politics. For Beuys, the foundation of a healthy society was the integration of personal and communal experience. Moreover, in his own work, he provided artists with a social model for dealing with their past. In a sense, Appelt is an example of what Beuys was calling for—someone who communicates, through form and a compelling choice of materials, the kinds of deep human emotions that are shared by others. His early photographs and live *aktions* point to primal and archaic themes. At the same time, they knock the wind out of us, making it impossible to look at them with detachment. Appelt's own experience, matched with his ability to draw inspiration from a wide range of aesthetic and historical sources, enables him to create work that evokes specific references but signals a more universal state of distress.

When Appelt was forty-seven, in 1982, he was appointed head of the department of film, video, and photography at the Hochschule für bildende Künste, where he had begun his studies more than twenty years before. When it came time to teach, he demonstrated a natural aptitude for the task. Aside from being a challenging and supportive teacher, he brought an energy to the job that evolved out of his own positive experiences with Rita Meinl-Weise and Heinz Hajek-Halke. Moreover, his teaching methods reflect his mentors' curiosity and penchant for experimentation. Students in the six-year program start out building their own cameras as a means of learning the basic principles and physics of photography. They also draw, paint, and make sculptures. Then they hone their skills and focus on one area of interest. Appelt sums up the interdisciplinary nature of the program in words that could apply to his own creative development, "It is easier to trim a full tree than to water a skinny growth."[29]

The mix of work Appelt produced in his first five years as a professor suggests that he was reminded, through teaching, how exciting experimentation could be. The series from this period are eclectic and daring. In *Canto I*, 1987, a reference to Pound's poetic works, Appelt plugs his mouth with his thumb, effectively silencing the chant—the canto—after which the piece is named (fig. 15). *Pitigliano*, titled after the Italian village where the pictures were made, is an aggressive attack on a woman's face that calls to mind the nihilistic acts of the Viennese Actionists (fig. 16).[30] And *Komplementärer Raum II* (*Complementary Space II*, 1988–89) registers his face—sometimes healthy, other times decayed—through crosshairs that read as the orientation device of a scientific instrument or the target-sight of a gun (pls. 30–33).[31]

At the spiritual end of the spectrum is *Die Präsenz der Dinge in der Zeit* (*The Presence of Things in Time*, 1984). To create a brilliant, supernatural glow, Appelt placed a mirror in his mouth and shined light on it (fig. 17). A former opera singer, Appelt has always

Figure 15.
Canto I, 1987

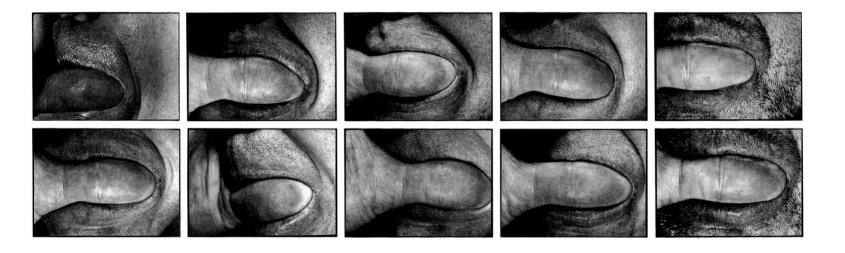

Figure 16.
Installation view of
Pitigliano, 1982
Städtische Galerie im
Lenbachhaus, Munich,
January 13–February 6,
1983

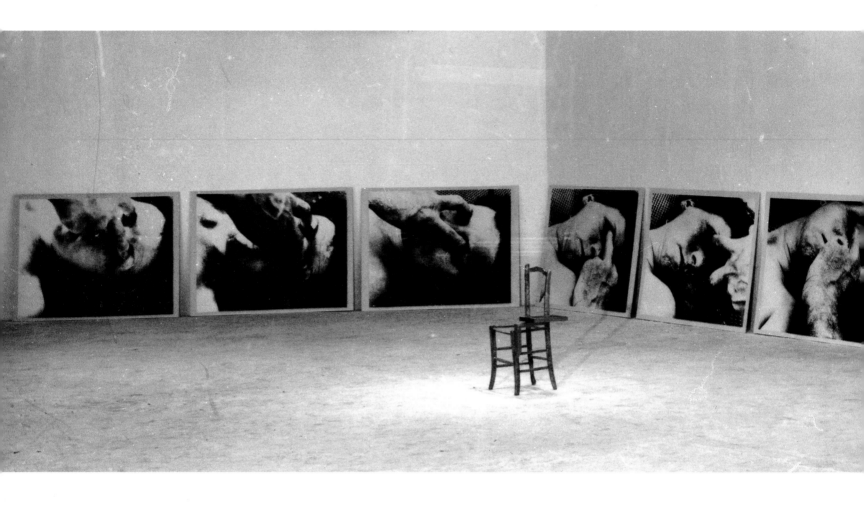

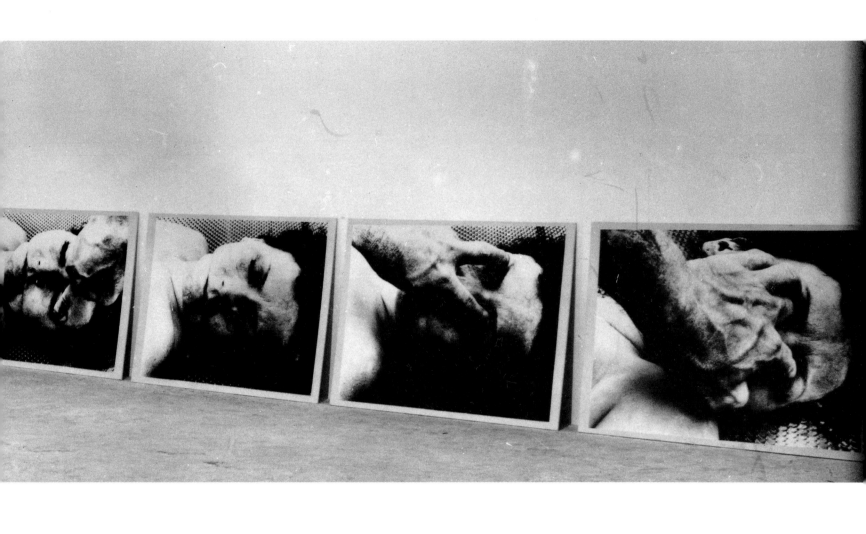

35

considered the voice to be an expressive instrument. Here, he speaks in light, not sound, as though an oracle or divine message emanates from within. From one image to the next, the light remains intense, but Appelt's face shudders with the force of what is inside.

In all of this work, Appelt pushed himself to his limits, once again in search of new form. During the 1980s, he evolved away from his theatrical and emotional pieces, toward a more mathematical and scientific approach to photography. He built images by making a single work out of multiple pictures and by making multiple exposures on a single sheet of film. Inspired by Futurist works, he integrated motion into his photographs in an effort to challenge the static nature of the still image and imply more than two dimensions in photography. Unlike his earlier work, where the visceral meaning is clear for all to see, these are more cerebral photographs, denser in concept and pictorial form. Having dug deeply into who he was in relation to the past, Appelt began to question who he is in relation to the universe.

A piece he made for a large group exhibition titled "Waldungen: Die Deutschen und ihr Wald" ("Forests: The Germans and their Forest," 1987) is a good example. The show contained over two hundred artists' works, ranging from images by the eighteenth-century painter Caspar David Friedrich to the twentieth-century artist Anselm Kiefer. In German art, literature, and mythology, the forest is a place of mystery and beauty, a place to fear and exalt. It is the home of fairy tales and the territory where German Romantics believed man tested himself against the elements and was confronted with his own nature.

Appelt's contribution to the exhibition was a multimedia piece that incorporated sound, photography, and digital images (fig. 18). The idea for the piece came when Appelt looked at the minute strip where the soundtrack runs along the side of a film, and in its jagged edge, he envisioned the treeline of a forest. All of us make this kind of visual association: we see animals in cloud forms and a face on the moon. But once our imagination has played its game of recognition, most of us are satisfied. Not Appelt. With the soundtrack's form in mind, he took a panorama camera to the edge of the forest and made dozens of photographs of the tree tops, then printed them and strung the pictures together. With what was now a long roll of photographs, Appelt fed the strip into a computer and digitized the images; then he made a videotape of the computer screen to register both form and sound. For the exhibition, he presented the photographs, titled *Waldungen: Partitur zur Waldrandabhörung (Forests: Score for Listening to the Forest)*, next to the video. When asked about how he developed the series of conceptual and formal leaps that led to this installation, Appelt has a simple explanation, "I was curious to see how the forest sounds. In this piece, you see what you hear and you hear what you see." He adds "The noise that played back sounded like cosmic noise, like what one might hear in outer space."[32]

Appelt's musical transformation of the forest is similar in spirit to the work of the Renaissance astronomer and astrologer Johannes Kepler, and the modern composer

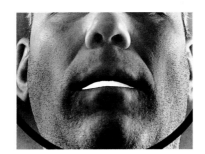

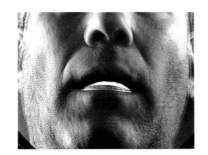

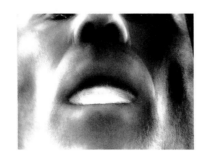

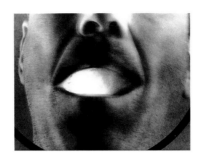

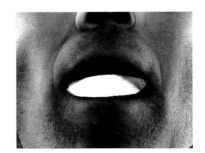

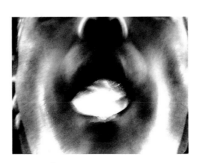

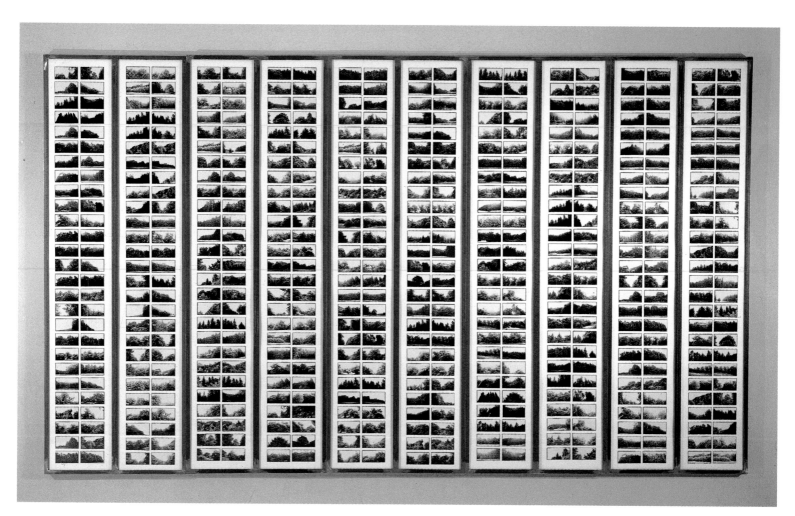

Figure 18.
Waldungen: Partitur zur
Waldrandabhörung
(Forests: Score for Listening
to the Forest), 1987/1994

38

John Cage. In 1619, Kepler developed a mathematical formula to prove that the orbit of planets around the sun, when charted on a musical scale, form a *harmonices mundis* (music of the spheres). The idea of a celestial harmony dates back to Pythagoras (around 550 B.C., Greece), but most often it was attributed to God or a pantheon of gods. Kepler imagined another answer, and through observation and mathematics, proved his point.[33] In the mid-1980s, Cage used a similar kind of inquisitiveness to formulate music derived from calligraphic drawings he made while meditating on the rocks and the ever-changing sand at Ryoanji, the same Zen garden that Appelt finds so compelling. Though one was a scientist and the other a musical artist, both Kepler and Cage had expansive views of research and experimentation. They pushed past ordinary deductive reasoning—Kepler, to understand the workings of the universe; Cage, to expand the definition of music to include all sound phenomena, not just tones traditionally organized by Western composers. In his piece for the exhibition on the German forest, Appelt displayed the same resourcefulness and innovative thinking. With his characteristic curiosity, Appelt went beyond conventional uses of the medium to give abstract principles a photographic form.

In the late 1980s, this kind of inventiveness dominated Appelt's creative efforts as his investigation of light, space, and time took center stage. In 1988, he began work on a massive, forty-part piece, *Tableau Space* (*Space Tableau*, 1989–90), for the 1990 Venice Biennale (pls. 34–38). Working indoors, in a studio equipped with sophisticated lighting and a machine he built to rotate objects before the camera, Appelt took photography back to the speed at which it was invented (fig. 19). For some of the pictures, he made his own

Figure 19.
Appelt's studio,
Berlin, 1990

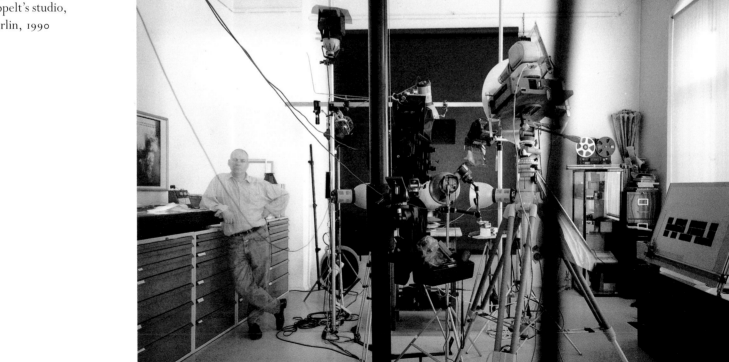

emulsion, a wet collodion concoction with an ASA of approximately 1.25—so slow it would barely register an exposure. He designed a tightly synchronized stroboscopic system to fire in his darkened studio. Then he placed found or handmade objects on the rotator and set them in motion. In many photographs, the object turns 360 degrees before the strobe goes off. In others, the object is exposed more often and at different intervals in the cycle. And sometimes the object is inverted or turned on its side for additional exposures. (Appelt often charted out the exposure factors in a notebook or made preliminary studies in the darkroom beforehand [fig. 20]). Throughout the making of *Tableau Space*, the camera is a passive participant. With its shutter locked open, it acts as receptor, not frame-maker, allowing for an accumulation of light and time that is unparalleled in contemporary photography: over a period of four hours, a single negative is exposed up to fifty thousand times.

The resulting pictures are large-scale prints (many of them positive and negative composites) of machine fragments and miscellaneous hardware that look like cosmic whirligigs and Cubist abstractions. In some images, the objects spin so fast and the strobe fires at so many different spots in the rotation that the object's form is not readable: its motion is the subject of the photograph. In others, the object appears to stand stock still, as though a single, rapid exposure recorded its form. Unlike the Cubists who show multiple views of a subject simultaneously to suggest, on canvas or on paper, what it is like to experience that subject in the real world, Appelt creates a new world for his objects which can only be seen through photography. "I want more from photography than a representation of what an object is," he says. "I want to transform the simplest constructions and create a new cosmos."[34]

Appelt loves to talk about how *Tableau Space* was made, though, as with all his discussions of his work, his description is not a linear narrative. In between references to the music of Czech composer Leos Janácek, and to the scientific studies of the relative size of things in the universe by Charles and Ray Eames, Appelt drops a word or two about f-stops and exposure times.[35] Given what went into the making of the piece, it is astonishing that none of the images reflect the intricacy of the process or the density of exposure, and all could have been made by simpler means. Why then does Appelt exert such rigorous control to make pictures of things that appear out of control?

He responds to this question by pointing to his interest in the early twentieth-century British art and literary movement, Vorticism, founded by Ezra Pound and Wyndham Lewis. (Wieland Schmied discusses Vorticism in his accompanying catalogue essay.) Appelt fully agrees with the maxim of Vorticism that each medium has a unique feature that, when used as the central element in art production, will result in the truest translation of that art.[36] For photography, light and time are the primary ingredients. Without light, there is no photography. And even with long exposures like Appelt's, an image embodies only a particular moment (or series of moments) in time. With this in

Figure 20.
Photogram study for
Tableau Space, 1989

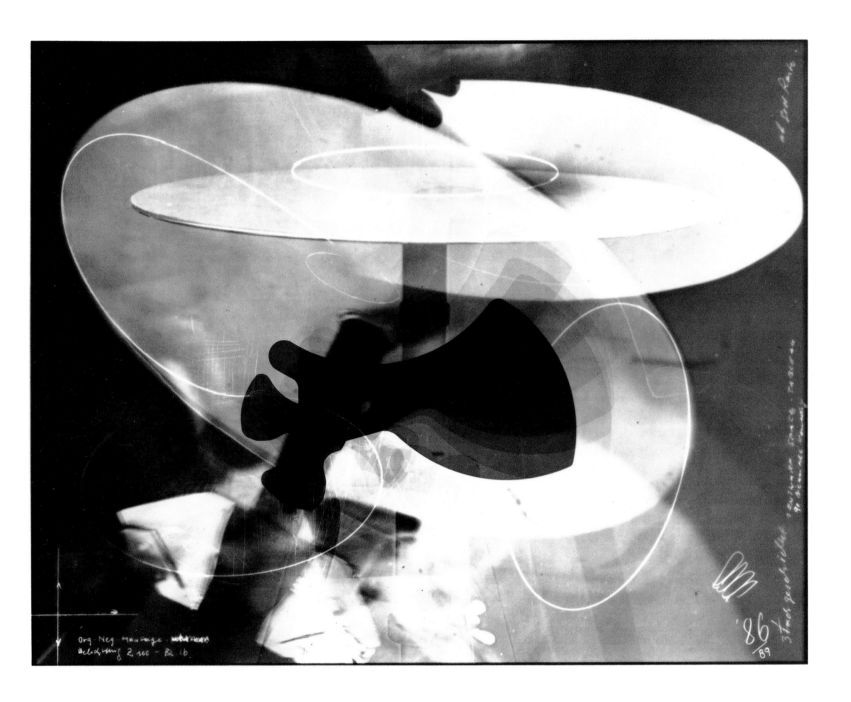

mind, Appelt has centered his attention on building light and time on film with a magnitude never before achieved: his goal—to develop a new pictorial language for photography. Despite his earlier rejection of a utopian agenda, Appelt does have hopes for the future of photography. He longs to break down barriers between science and art and to clear away previous notions of what a photograph can be. As inspiration, Appelt quotes a line from *The Marriage of Heaven and Hell* by William Blake, "If the doors of perception were cleansed, everything would appear to man as it is: infinite."[37]

While Appelt was working on *Tableau Space*, the Berlin Wall came down in 1989. Among the changes brought on by the unification of Germany was an opening of new perspectives on the past. Some initiatives were directed at honoring victims of Hitler's regime. In 1992, the German government held a competition for a sculpture to be built on the grounds of the Reichstag to commemorate the members of Parliament who were persecuted, imprisoned, or killed by the Third Reich in the 1930s. Appelt submitted a design and won the competition. With *Denkmal für die ermordeten Reichstagsabgeordneten (Monument for the Murdered Parliamentarians)*, 1992, he turned to the history of Nazi Germany, treating the subject with humility and respect. Appelt's monument is made of gray, broken, cast-iron tablets, one for each of the eighty-seven persecuted members of Parliament (fig. 21).[38] The thin upper edge of each slab is engraved with members' names, political affiliations, and the dates, sites, and circumstances of their deaths. Positioned low to the ground to the

Figure 21.
Denkmal für die ermordeten Reichstagsabgeordneten (Monument for the Murdered Parliamentarians), 1992
Memorial in front of Reichstag, Berlin
Cast iron in cement

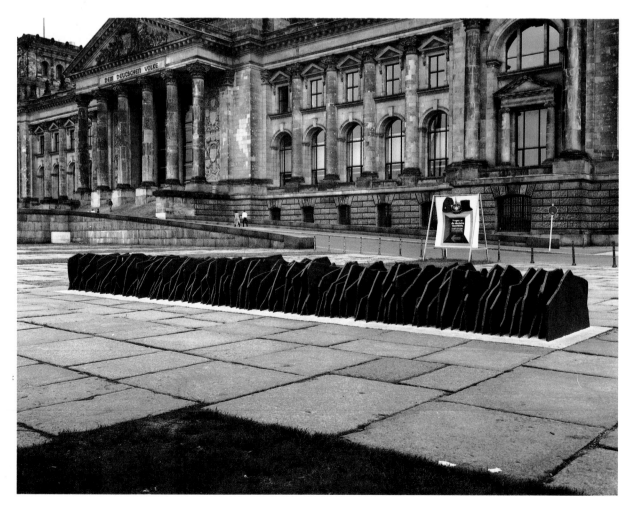

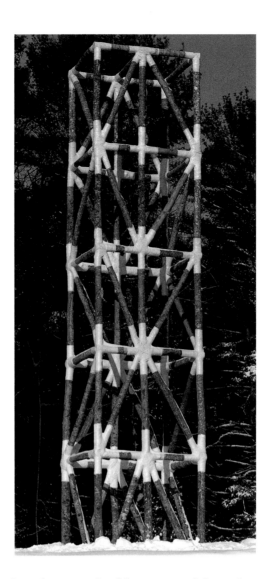

Figure 22.
Mainetower, 1992–93
Arrowsic, Maine

right of the neoclassical Parliament building, Appelt's sculpture is a discrete and somber memorial, cold and elegantly beautiful.

Appelt made a site-specific sculpture of a different kind on friend and gallery owner Rudolf Kicken's tiny island in the inland waterways along the coast of Maine. Weighing two tons and standing twenty-eight feet high, *Mainetower* can be seen from the water, reminding boaters of a watchtower, a totem, or a widow's walk (fig. 22).[39] A massive structure, *Mainetower* is a far cry from the delicate asymmetry of Appelt's earlier tower *Augenturm.* Compared to the assertiveness of *Mainetower, Augenturm* resembles a newborn calf testing its weight on fragile legs. In 1977, Appelt made *Augenturm* by hand as a temporary scaffold to interact with and to photograph. Today, only a small portion of it remains as a relic, dismantled and tied in a box at the Berlinische Galerie, Berlin. By contrast, *Mainetower* was built by three carpenters as a permanent sculpture designed to weather with age, and Appelt has no intention of posing with it. In their differences, the two towers stand as coastal markers, charting progress and signaling the artist's concerns at the time they were made. When he built *Augenturm,* Appelt was groping through the past, working intuitively, spontaneously, and the tower's form reflects the fluidity of his thinking. Since then, his impulsive maneuvers before the camera have given way to measured experiments in light, space, and time, and *Mainetower* exemplifies the studied precision of his most recent works.

Appelt's current interests are reflected in a series of pictures he began in the early 1990s called *Felder (Fields)*. The first in the group, *Das Feld (The Field*, 1991), contains thirty photographs of water swirling and bubbling below the camera (pls. 40–42). Printed in heavy leaden grays, each image has a turbulent, metallic beauty of its own. Seen together, the photographs read as an aerial survey of an undulating sea of mercury. Unlike *Tableau Space*, which took Appelt two years to complete, *Das Feld* was made in thirty minutes. On a bridge in southern Germany looking down on the Wiesent river, he made an exposure every sixty seconds: one minute, one picture. "This is an absolute transcription of a childhood memory. I used to sit on boulders in the river behind our farm and watch the whirl and movement of the water. I have spent years looking for a river like this: a place where the current is fast, the water is clear, and the light is extreme."[40]

While the impetus for making *Das Feld* was an experience from Appelt's youth, the idea for *Steinfeld (Stone Field*, 1994) came from a chance passing by a roadside rock face that was covered with mesh to prevent loose rocks from falling on the road. In response to this sight Appelt built several sculptural objects out of Italian limestones set in hand-made wooden casings. Then, as with *Tableau Space*, he rotated each object before the camera to make complex, multiple exposures (pls. 47–49). The wood, zig-zagging across the sparkling stones makes irregular patterns, ressembling a diagram of a molecular structure gone awry. For the third in the *Felder* group, Appelt took pictures in the woods of Vancouver, Maine, and Germany. Another gridded piece, *Kreuzweg (Crossroad,* 1993), contains twenty-four pictures; each is a composite of positive and negative views of tangled twigs and branches (pls. 43–46). For some of the images, Appelt rotated the camera while taking the picture, then rotated the photo paper under the enlarger during exposure. The effect is a swirling sense of vertigo. In this jumbled nest of twigs and branches is a force that pulls us in and pulls the photographer back to his roots. When Appelt named this series *Felder*, he had Vorticism, physics, and quantum field theory in mind.[41] But the series reminds us that it was in fields that Appelt developed his love of nature, took his first photographs, and had his most formative early experiences.

Aside from teaching and working on the *Felder* series, which have taken up most of his time in recent years, Appelt has also made several pieces inspired by work from the first years of his photographic career. Nearly two decades after making the picture he calls "the beginning," he has returned to previous motifs, as though to test his current knowledge and experience against earlier perceptions. In 1992, he reworked *Membranobjekt*, from *Erinnerungsspur,* 1977–79 (pl. 15), creating new images from old negatives and applying what he has learned about multiple-exposure techniques (fig. 23). In *Zirkulationsfeld (Circulation Field*, 1993), he touched base with one of the earliest subjects of his career when he used a handmade cage-like structure to contain his head (fig. 31). The most recent resurrection of past ideas is a regeneration of a group of photographs from 1977

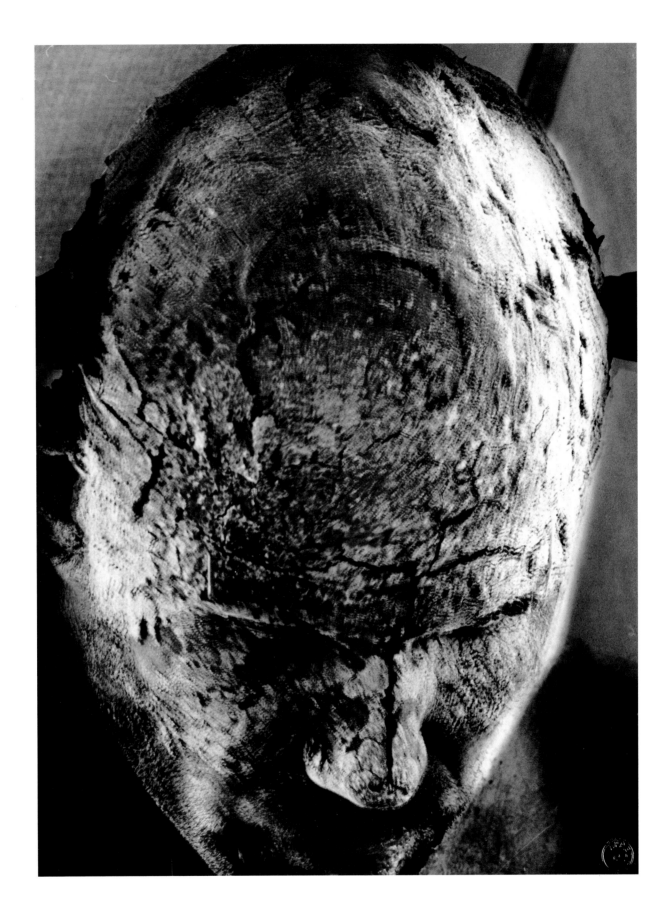

Figure 23.
Membranobjekt
(Membrane Object),
from *Erinnerungsspur*
(Memory's Trace),
1977–79/1992

45

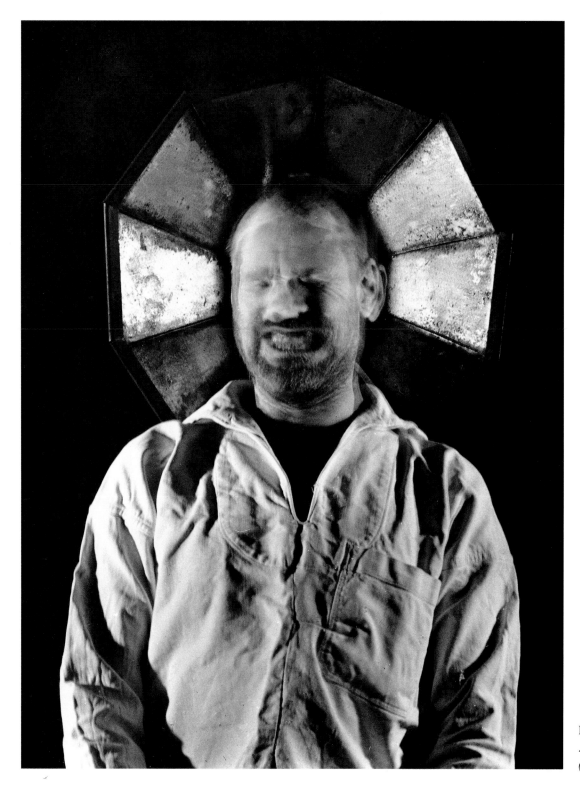

Figure 24.
*Spiegelfächer I
(Mirror Fan I)*, 1977

called *Spiegelfächer I (Mirror Fan I).* The original pictures were of Appelt grimacing, his head surrounded by a halo made from a small flashbulb reflector he found in a flea market (Appelt fit the reflector and his form together in a multiple exposure; fig. 24). The early pictures are expressionistic, purging, extreme. By contrast, the ones he is currently producing are phenomenological. To make them, he built a full-sized replica of the flash reflector, this one true to his body's scale. He angled each piece of the fan forward so that, when put together, it would record his head in eight different orientations simultaneously (fig. 28). Appelt plans to photograph himself at its core, his reflection fanning out around him. What was a halo in the earlier piece will become a colossal aura, reflecting the artist's conceptual and aesthetic ambition. Still preoccupied with theories of Vorticism, Appelt refers to the mirror fan as a "vortex"—a whirl, a spiral that has a gravitational pull all its own. An apt metaphor, the mirror fan is designed to encircle Appelt's body, placing him as the source of the centrifigal force, at the center of his art.

When asked to relate his new work to past photographs, Appelt cites the relationship of a satellite to its power station. He uses circular gestures and a clicking sound to illustrate that the satellite floats freely with a function and purpose of its own, but when it returns to the mother ship, it locks in place with a perfect fit. By resurrecting motifs from the past, Appelt connects with the power station that his earlier work has erected. As he has done throughout his career, he makes use of the resources that lie within his own experience, only this time, he finds energy and inspiration in his art. Virginia Woolf wrote of just such an exercise as one of the triumphs of maturity. In the voice of Peter Walsh, a Londoner in his fifties who appears in her novel *Mrs. Dalloway*, she characterizes the perspective and insight that come with age. Appelt, now nearing sixty, fits the profile. "The passions remain as strong as ever, but one had gained—at last!—the power which adds the supreme flavour of existence,—the power of taking hold of experience, of turning it round, slowly, in the light."[42]

On my first trip to work with Dieter Appelt in Berlin, he took me to the Martin-Gropius-Bau, a massive Italian Renaissance-style building in Kreuzberg that now houses two museums and a large archive of architectural drawings. After visiting the museums, we went around to the back of the building to see where the Berlin Wall had once run. Though it had come down over two years before, Appelt marveled—not at the change in the landscape or in the social or political ramifications of the event—but at the fact that we now stood on the spot where the wall had once been. Sites charged with history remain a source of fascination for Appelt and he wandered off, scanning the ground for interesting objects to photograph. I saw then that the act of looking is central to his creativity. To Appelt, art is a path to discovery and a process of finding form for the invisible forces that lie beyond human experience. It is a means of simultaneously digging deep inside and seeking beyond himself to discover the interconnectedness of things in the universe. In this, his

creative process can be likened to a central principle of Zen: it is not the destination that is the goal, but the journey that is the source of enlightenment. I got my first glimpse of this that afternoon in Kreuzberg, while watching Appelt scan the ground with thorough absorption. Dieter is an intensely hospitable man, and it was not like him to leave a guest unattended. But, as he crouched to examine a rusted metal object, I realized that my tour had ended, and his journey had begun.

Notes

1

All biographical information in this essay was obtained through interviews with the artist between July 1992 and May 1994. Interviews were conducted in German. Tapes were translated and transcribed in Chicago by Birgit Rathsmann (Olivia Gonzalez provided a preliminary translation for the first of fifteen tapes).

2

Appelt, in conversation with the author, March 1993.

3

Late-nineteenth-century novelist Karl May's books were so popular that by the time he died in 1916, 1.6 million copies had been sold. That figure rose to over 11 million by the 1970s. See Gordon A. Craig, *The Germans* (1982; rpt. New York: Meridian, 1991), p. 200.

4

Arnold Schoenberg's twelve-tone music, developed in the 1920s, was a radical departure from traditional compositional technique. Unlike Western music based on eight tones and structured in octaves, Schoenberg's method uses twelve tones. All are given equal weight, which is why twelve-tone music sounds so unfamiliar. Many listeners describe it as atonal, but Schoenberg preferred the less derogatory term, "pantonal." See Carl Dalhaus, *Schoenberg and the New Music* (Cambridge and New York: Cambridge University Press, 1987). One of Appelt's favorite operas, *Wozzek,* was produced by Schoenberg's student, Alban Berg. Adapted from Georg Büchner's play in 1925, *Wozzek* is rich in emotional drama and incorporates key elements in opera: human failings, remorse, wrath, and liberation through death.

5

In his lively overview of German history and culture, Gordon A. Craig writes of those who left the German Democratic Republic: "Between 1949 and early 1961, the exodus averaged 230,000 a year....The causes of this were obvious enough. The never-ending heresy-hunting and horrendous penalties meted out for supposed crimes against the State...the unrelieved thought control, and the tedious nagging by party watchdogs made life in the DDR intolerable for spirited and talented people." Craig (note 3), p. 52.

6

Heinz Hajek-Halke, *Experimentelle Fotografie* (Bonn: Athenäum-Verlag, 1955), p. 7.

7

Appelt, in conversation with the author, February 1994.

8

For an account of art activities in Berlin during this period, see Kynaston McShine, ed., *Berlinart, 1961–1987* (New York and Munich: The Museum of Modern Art and Prestel Verlag, 1987).

9

The *aktion* took place at the Festival of New Art, in the Audimax at the Institute of Technology, Aachen, on July 20, 1964. For a more detailed description of the event, see Heiner Stachelhaus, *Joseph Beuys*, trans. David Britt (New York, London, and Paris: Abbeville, 1991).

10

Appelt, in conversation with the author, September 1993.

11

Appelt, in conversation with the author, April 1994. Appelt's fascination with Ryoanji was shared by John Cage. Cage visited the garden in 1962 and in the mid-1980s, he produced a series of drawings called "Where R = Ryoanji." In addition, he created works for simple instruments, called "Ryoanji," that were derived from drawings he made at the garden. David Revill, *The Roaring Silence: John Cage: A Life* (New York: Arcade Publishing, 1992).

12

Daisetz T. Suzuki, *Zen and Japanese Culture* (Princeton: Princeton University Press, 1959), p. 10. For another insightful book into Zen, see T. P. Kasulis, *Zen Action / Zen Person* (Honolulu: University of Hawaii Press, 1981).

13

Appelt, in conversation with the author, October 1992.

14

To make his self-portraits, Appelt sometimes worked alone with a cable-release, but often his wife Hanna operated the camera. In fact, she worked through the thinking and the making of much of Appelt's art. For the series *Erinnerungsspur*, in particular, he views her as his aesthetic and conceptual collaborator.

15

Appelt (note 13).

16

This image draws its title from a line in Raymond Roussel's book *Impressions d'Afrique* (Paris: Lemerre, 1910), "the mark on the mirror breathing makes." For an English translation, see *Impressions of Africa*, trans. Lindy Foord and Rayner Heppenstall (Berkeley and Los Angeles: University of California Press, 1967).

17

When Appelt decided to focus his attention on photography in the late 1970s, he destroyed the paintings still in his possession, some thirty canvases in all. A few remain in private collections.

18

Quetzalcóatl was the peaceful ruler turned god of the Tula region who endowed the Toltecs with knowledge and agricultural abundance and is represented in mythology by a feathered serpent.

19

Appelt intended to leave *Haus in Oppedette* on site for a year, then take it down and exhibit it as a weathered and decayed relic from nature, but when he returned the house was gone. Appelt later reconstructed it from memory in the model shown here, which he frequently exhibits with photographs of the original construction.

20

Ezra Pound, ed. and trans., *Confucius: The Great Digest and Unwobbling Pivot* (New York: New Directions, 1951).

21

Canto 110 is excerpted from *The Cantos of Ezra Pound* (New York: New Directions, 1970), p. 781. The Chinese character, 日, is romanized as jih in the Wade-Giles system used by Mathews, and ri in the Pinyin system used in mainland China today. It translates as "The Sun. A Day. Daily." The notation 4.5 indicates what tone should be used in pronouncing the character. See Mathews Chinese-English Dictionary (1931; revised American edition, Cambridge: Harvard University Press, 1969), p. 468. I am grateful to Elinor Pearlstein for her knowledge about the Chinese written and spoken language.

22

Sanford Schwartz, *The Matrix of Modernism* (Princeton: Princeton University Press, 1985). See also Christine Froula, *A Guide to Ezra Pound's Selected Poems* (New York: New Directions, 1982).

23

Die Symmetrie des Schädels was performed on January 16, 1977, at the Galerie Georg Nothelfer, Berlin. The performance is documented in a catalogue published by the gallery.

24

At one point, Appelt tied a fox skull to his waist. Although he did not intend it as such, he now views this as a reference to a Joseph Beuys performance, called "Coyote: I Like America and America Likes Me," in which Beuys lived with a coyote in the René Block Gallery, New York, for one week in May 1974.

25

Black Box was performed at Galerie Marzona, Düsseldorf, in 1978; at Hamburger Kunstverein, Hamburg, in 1979; at *Symposium International d'Art Performance,* Lyons in 1980; and at *ARS '83,* at Ateneumin Taidemuseo, Helsinki, in 1983. The first black box was iron and the others were made out of wood. The approximate dimensions of each box was seven and a half feet long, four feet wide and two and a half feet high.

26

For an in-depth account of Viennese Action works, see Günter Brus, et al., *From Action Painting to Actionism: Vienna, 1960–1965* (Klagenfurt: Ritter Verlag, 1988), and Hubert Klockner, ed., *Viennese Aktionism, Vienna, 1960–1971: The Shattered Mirror* (Klagenfurt: Ritter Verlag, 1989).

27

Appelt (note 2).

28

Appelt (note 10).

29

Appelt, in conversation with the author, July 1992.

30

Appelt got the idea for this piece from rituals he observed in Pitigliano of closing the eyes of the deceased and wrapping thread around the mouth to keep it closed in death.

31

The empty spaces in *Komplementärer Raum II* 1988–89, resulted when Appelt removed images he felt did not contribute to the whole. He now views the spaces as musical pauses in the overall composition.

32

Appelt (note 2). In 1994 Appelt made a second version of the photographic piece, *Waldungen: Partitur zur Waldrandabhörung*, which is pictured here. The video and digital film are titled *Waldrandabhörung (Listening to the Forest)*.

33
Kepler's theory on music of the spheres was published as *Harmonices mundis (Music of the Spheres)* in 1619. See Fernand Hallyn, *The Poetic Structure of the World: Copernicus and Kepler* (New York: Zone Books, 1990). I am grateful to Robert Sharp for directing me to theories of celestial harmony.

34
Appelt (note 29).

35
Charles and Ray Eames' study on the relative size of things in the universe was a strong influence on Appelt in the late 1980s. The study has been distributed in book and film form under the title *The Powers of Ten*. The film is circulated by The Office of Charles and Ray Eames. The book is an expanded version of principles brought up in the film: Philip and Phylis Morrison and The Office of Charles and Ray Eames, *The Powers of Ten* (New York: Scientific American Library, 1982).

36
Reed Way Dasenbrock, *The Literary Vorticism of Ezra Pound and Wyndham Lewis* (Baltimore and London: Johns Hopkins University Press, 1985).

37
From William Blake's *The Marriage of Heaven and Hell*, plate 14. See Mary Lynn Johnson and John E. Grant, *Blake's Poetry and Designs* (New York: W. W. Norton, 1979), p. 93.

38
The sculpture was built with the assistance of three of Appelt's students, Justus Müller, Christian Zwirner, and Klaus Eisenlohr.

39
Mainetower was designed by Appelt and constructed by Robert W. Stevens and his assistants Paul and Owen Pierce on Arrowsic, Maine, between October 1992 and March 1993. It is composed of beech wood native to the island and Appelt's trademark linen strips. As with all of his sculptures, no nails or metal hardware was used.

40
Appelt (note 11).

41
In quantum field theory, a positive and negative force are matched and the charge between them is created or destroyed by a single event.

42
Virginia Woolf was in her mid-forties when she wrote *Mrs. Dalloway* (New York: Harcourt, Brace & World, 1925), p. 119. I am grateful to David Travis for bringing this quotation to my attention.

LIGHT AND TIME: THE PHOTOGRAPHIC WORK OF DIETER APPELT

by Wieland Schmied

Among our many basic impulses, there are two opposing desires that are inherent in human nature. One is the desire to accelerate time and live out tomorrow or the day after tomorrow right now; the desire to skip over several years, to have already achieved this or that, or to have finished something—an examination, one's professional career, a marriage, the birth of one's children—until, as in a tale by Franz Kafka, one is startled to realize that in the meantime, one has left out one's whole life.

The second desire — no less developed and just as old and deeply rooted— is diametrically opposed. This is the longing to slow time down, to enjoy the present moment to its fullest, to prolong the blissful hour as much as possible, and let the present never end. Ultimately, it is a desire to stop time and bring it to a standstill. For, as we hear in Friedrich Nietzsche's "Mitternachtslied" (Midnightsong), all desire wants eternity, deep, deep eternity.

Everyone, of course, experiences the painful realization that both of these desires are just as unattainable as the ability to be in two places at once. Man is powerless against the phenomenon of time. Or to use another metaphor: he is embedded in the flow of time and with it, he passes on. All things are in a state of flux, says Heraclitus, including ourselves, even as we muse upon this very sentence.

Such is the human condition. Man has to learn to live with the conditions of space and time. He can neither accelerate nor stop the course of time. He can neither transfer himself into the utopian Arcadia of a remote future nor delay the hour of his death. He can do nothing about time. Whether he resists or not, he is at its mercy. Never-

theless, he cannot help himself from devising strategies of resistance. If he has to be exposed to time; he at least wants to be able to manipulate its course a bit. For this purpose, man has invented the instrument of technology to help him outwit time, by covering great distances at high speed, or with the aid of advanced medical knowledge, by extending his life as long as possible. Other strategies aim less at outwitting time than at refining our perception of it, sharpening our senses to its nature, and deepening our knowledge of its effect. Here is where the role of the photographer begins.

The capacity of photography to render visible and direct our attention to the passage of time is less than that of film. Photography cannot achieve what film apparently can—to accelerate or slow down the course of time. Fast motion and slow motion, those two classic film techniques of manipulating time, are not at the photographer's disposal. The trump card of photography is the snapshot, which fixes the reality of a certain instant. But the snapshot cannot convey the impression of the static and the permanent. It appeals to our memory and keeps it alert. It does not say "this is the way it is, this is how things shall remain"; instead, it always says "once upon a time this is how it was." And it often adds the message that the past is irretrievable. By showing the past, it reminds us of the transience of our existence and makes us nostalgic.

The photographic technique of long exposure times or multiple exposures penetrates deeper into the nature of time than does the instantaneous photograph, its extreme opposite, which invariably captures only a superficial reflection. While the snapshot works against time, the photograph with extended exposures works with time. While the instantaneous photograph seeks to catch time unawares (with only apparent success), the photograph with long or multiple exposures lets time work for itself. Moreover, it enables time to depict itself, to make its progress visible, to reveal its appearance.

This is where Dieter Appelt enters the scene, for making time visible and thus comprehending time are not only the specific subjects of his photographs, but the secret axis around which his work continually moves. Appelt's art follows two impulses. On the one hand, it aims at sharpening our perception of time as a subjective factor, while on the other hand, it aims to illustrate its effect and to track down its manifestations as an objective factor.

Time itself is not visible. It needs two things in order to be visualized through the hand of man: matter (whether solid, fluid, or gaseous) and light. For good reason, someone who deals with the medium of photography is called a sculptor of light. He sculpts by means of light and forms light itself. He needs light. He is able to capture it, change it, and give it shape by the interaction of matter and time. Thus, light loses its unlimited character and gains shape. For Dieter Appelt, light and time are basically linked and cannot be separated. In making time visible he lends permanence to light; light even becomes a guarantor of permanence to him. He who trusts in light to that degree, becomes familiar with the dimension of time.

This brings us to a specific work by Appelt, *Die Schatten erinnern an nichts I* (*The Shadows are Reminiscent of Nothing I*), created in 1991 (fig. 25). The piece consists of three tableaus—each one a photographic canvas mounted onto a stable panel behind glass; each measuring 120 x 100 cm. Together they form a triptych in a limited edition of three. The tableaus on the right and in the middle represent the same object, while the tableau on the left shows a segment of a human body with an arm hanging down. The hand is particularly accentuated, like the creator's hand, to which the object of the image owes its origin.

The object in the other two images remains mysterious. It can barely be deciphered. It recalls the form of a head placed upon a double cylindrical pedestal of stone. Appelt fashioned it from a ball of dough, mounted on a neck, tightly bound, and baked to keep its shape. It is a head without a face, a globe without an ocean. This spherical object is placed upon a movable turntable and set into motion before the camera. Only in constant rotation does it gain its actual shape. The main element, however, is still lacking: light. Brought in from different sources, light is irregularly reflected off the roughened and cracked surface of the rounded form. The light seems to be subdued, its sources are dimmed, there are no spotlights in operation. It is the twilight hour that opens our eyes. At twilight the owl, the bird of Minerva, starts its flight.

Now, an interplay of light and shadow begins. There are no hard shadows and the shadows that do exist are soft and supple: they are siblings of light. Matter absorbs light and reflects light. Twilight condenses and blurs. Spots of light brighten the shadows. Areas of shadow darken patches of light. When the ball is rotating on the turntable, light and shadow cross and interweave into matter, making matter transparent. Form appears as matter becomes transparent. The light in matter turns into energy and radiates. Things dissolve in the light, they begin to flow and stream. But the shadows remain. The shadows seem to be the only reality. Everything else is intangible and its hold on us increases the more it evades us and withdraws into the twilight.

There is another motion that corresponds to the rotation of the mass on the turntable: this is the motion of the aperture in front of the camera which opens and shuts the lens at variable intervals. In rhythmic motion, long and short exposures are repeated over and over again. Thus, the same negative is exposed several thousand times. It is hard to imagine an image more complex than one created in this way. No photographer before Dieter Appelt has succeeded in making an image of reality, light, time, and matter of such complexity by such simple means.

Yet the product is more than just the complex result of a photographic endeavor. It is an image of sculpture so perfect that it might have come from the studio of Brancusi. Its secret is motion presented as inertia, the greatest possible motion as the greatest possible inertia. The opaque becomes diaphanous, the surface polished; shadows glow and twilight makes things visible. Light falls like snow on the cracked surface of the

Figure 25.
*Die Schatten erinnern an
nichts I (The Shadows Are
Reminiscent of Nothing I)*,
1991

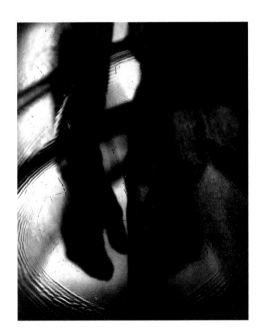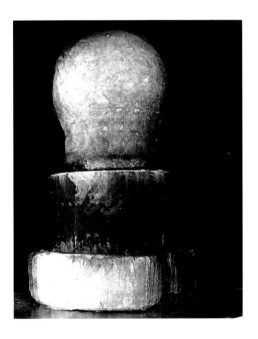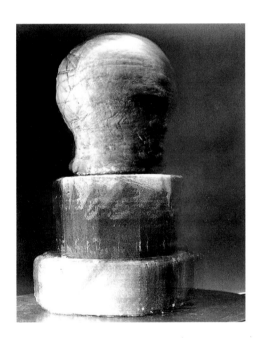

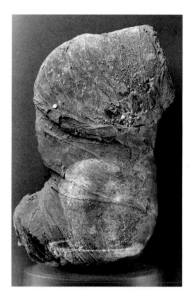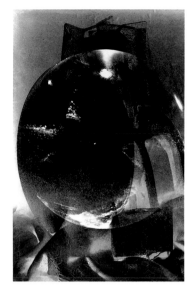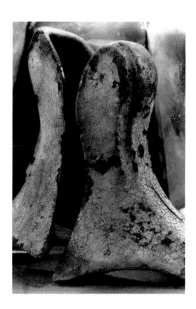

Figure 26.
Vortex, 1992

rotating object; at rest in its rotation, layers of light cover it like blankets of snowflakes. A perfect balance seems to be achieved, a balance between life as motion, as process, and its eventual goal, to which all restlessness will lead some day when motion is exhausted; a balance between matter and form, reality and image, space and light.

As I have already mentioned, accelerating time and stopping time can be regarded as inherent and inescapable desires of mankind. In the field of art, Dieter Appelt has achieved both with his photographic work, or rather, he has fulfilled one by means of the other. The complex artistic process he developed is based simply on the consistent application of the concept of accelerating time. His result, however, is an image of halted time, of inertia, of pure permanence. By opening and closing the shutter at changing intervals, one shot following the next, one layer of light after another recorded on the photographic plate, Appelt selectively excerpts segments of time. Using this form of time-lapse photography, he ultimately accelerates time, collapsing and condensing it. The result—a photographic image composed of thousands of exposures, thousands of layers of light—is time halted. It is the accumulation of time, the conglomeration of time. The photograph is no longer an image of something that exists outside of it. Appelt has said, "A snapshot steals life that it cannot return. A long exposure gives a form that never existed." This form constitutes a new reality, and that reality is the perfect sculpture. It is not a sculpture of matter and motion, but something different, a body composed of light and time.[1]

"Vortex"

Everything that has been said about Appelt's 1991 photographic work *Die Schatten erinnern an nichts I* also applies to *Vortex*, a sequence of images developed soon afterwards in 1992 (fig. 26). This piece consists of seven photographic tableaus that further elaborate the subject of light and time. Once again, as in *Die Schatten erinnern an nichts I* and his series

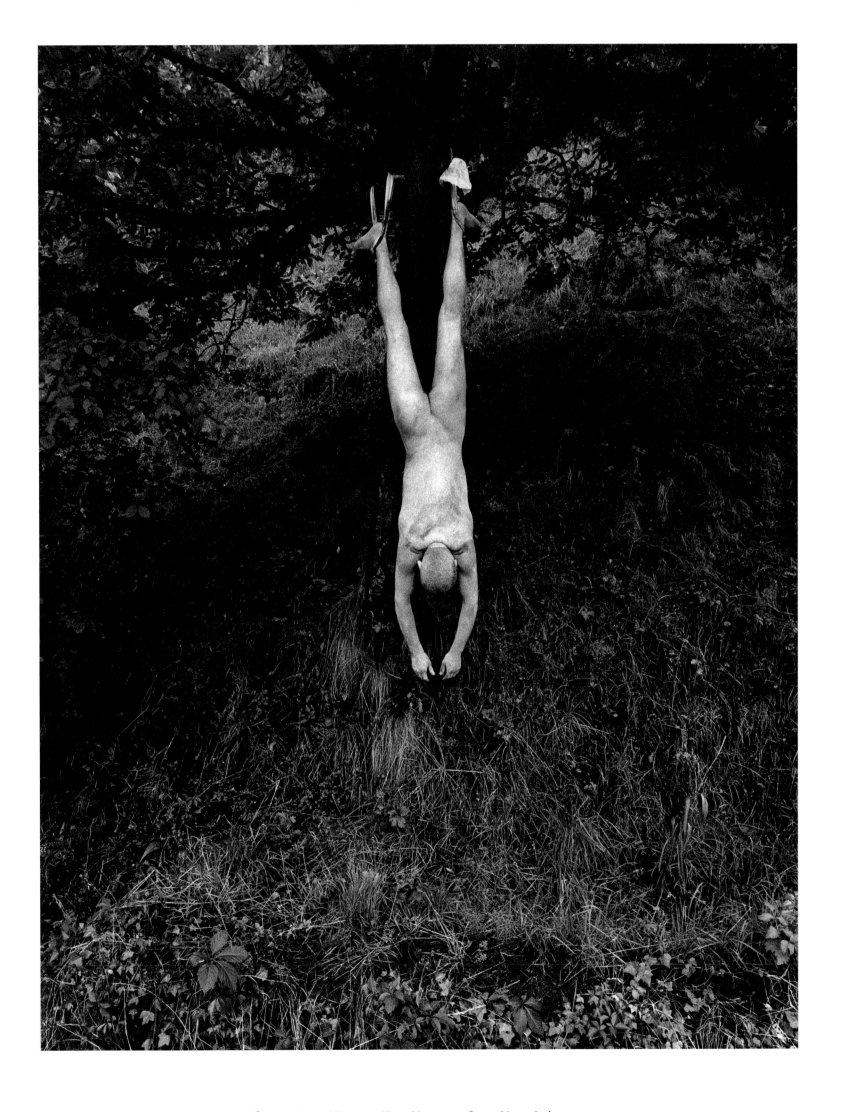

Plate 1. *Erste Hängung (First Hanging)*, from *Monte Isola*, 1976

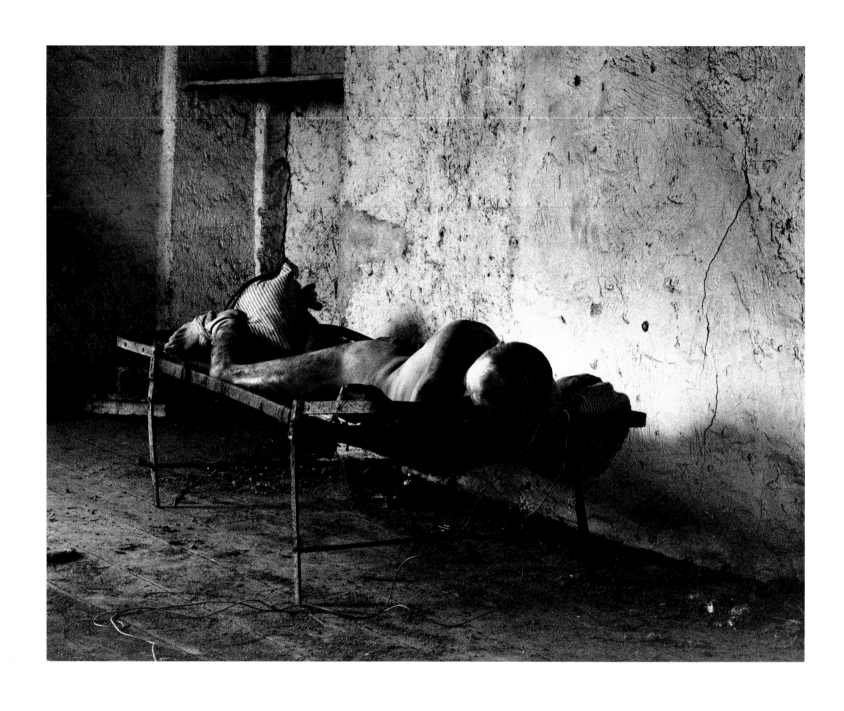

Plate 2. From *Monte Isola*, 1976

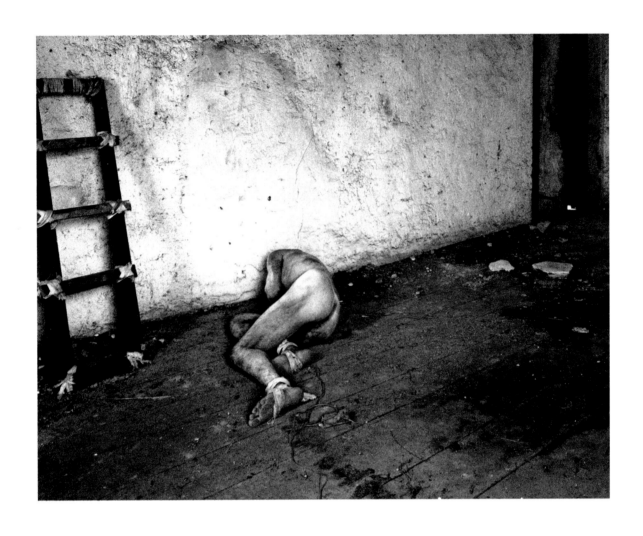

Plate 3. From *Monte Isola*, 1976

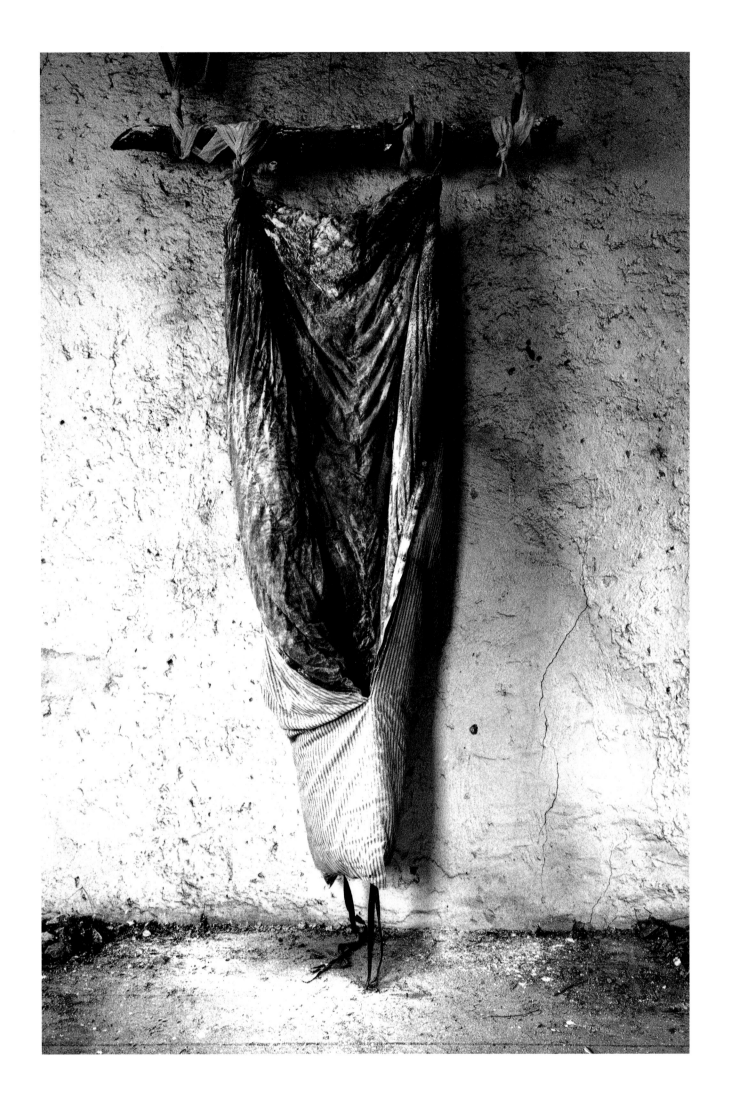

Plate 4. From *Monte Isola*, 1976

Der Augenturm

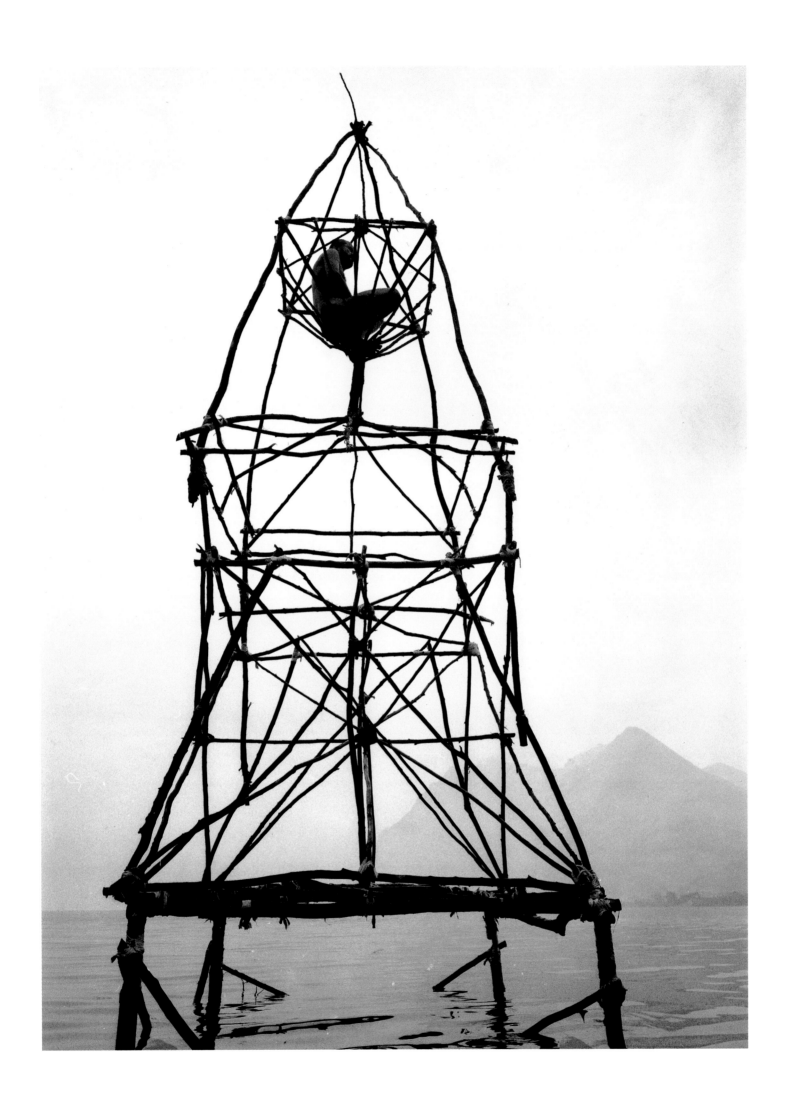

Plate 5. *Der Augenturm (Eye Tower)*, 1977

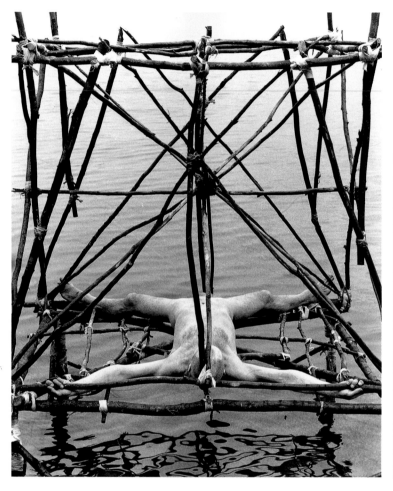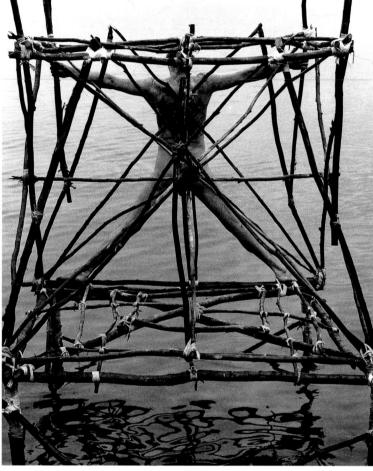

Plates 6–9. *Der Augenturm (Eye Tower)*, 1977

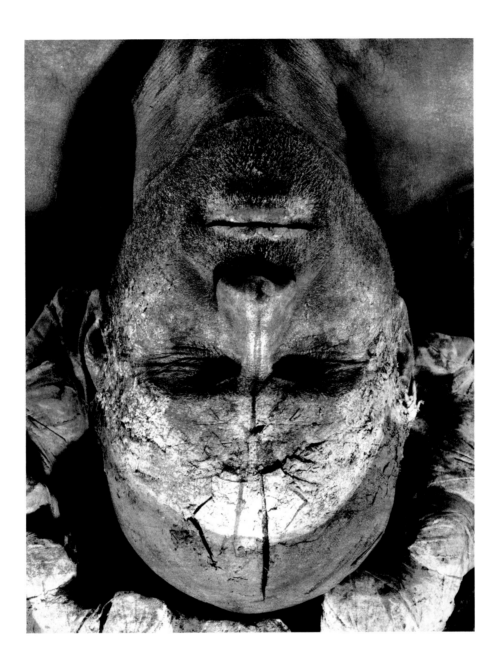

Plate 12. From *Erinnerungsspur (Memory's Trace)*, 1977–79

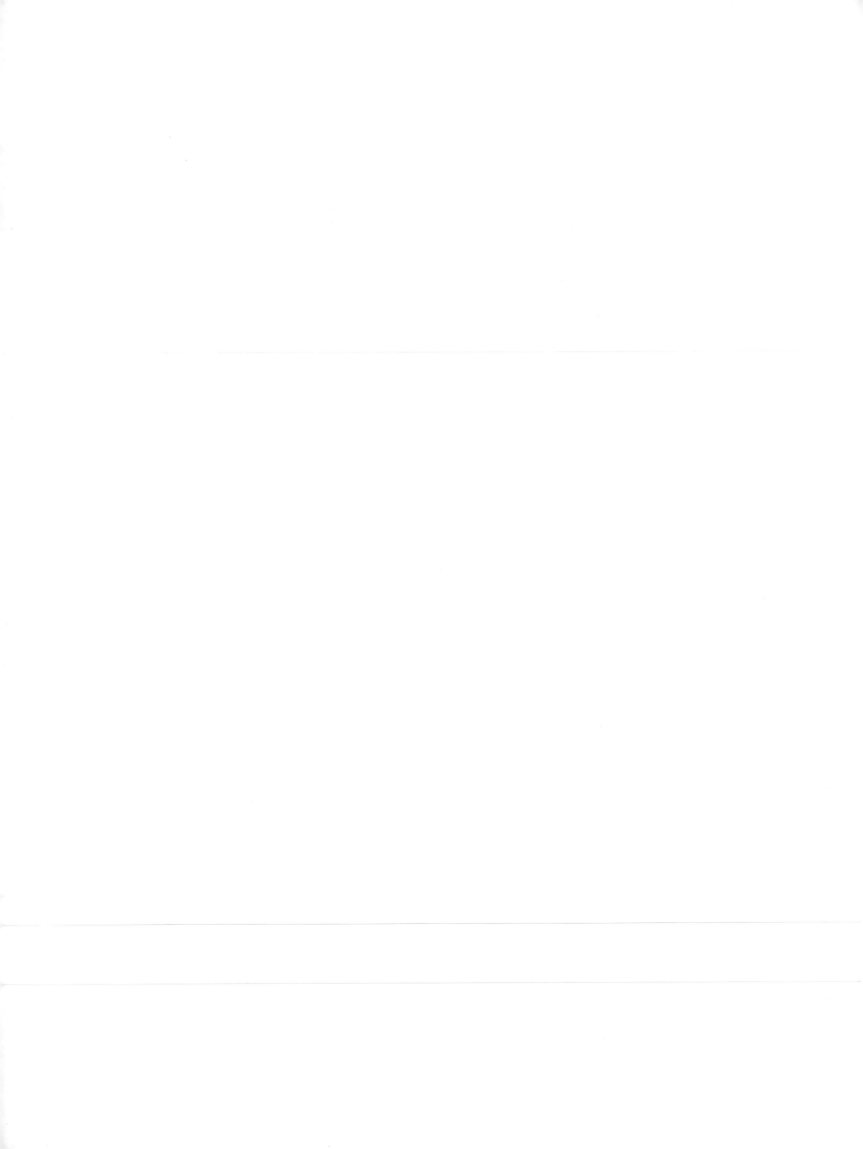

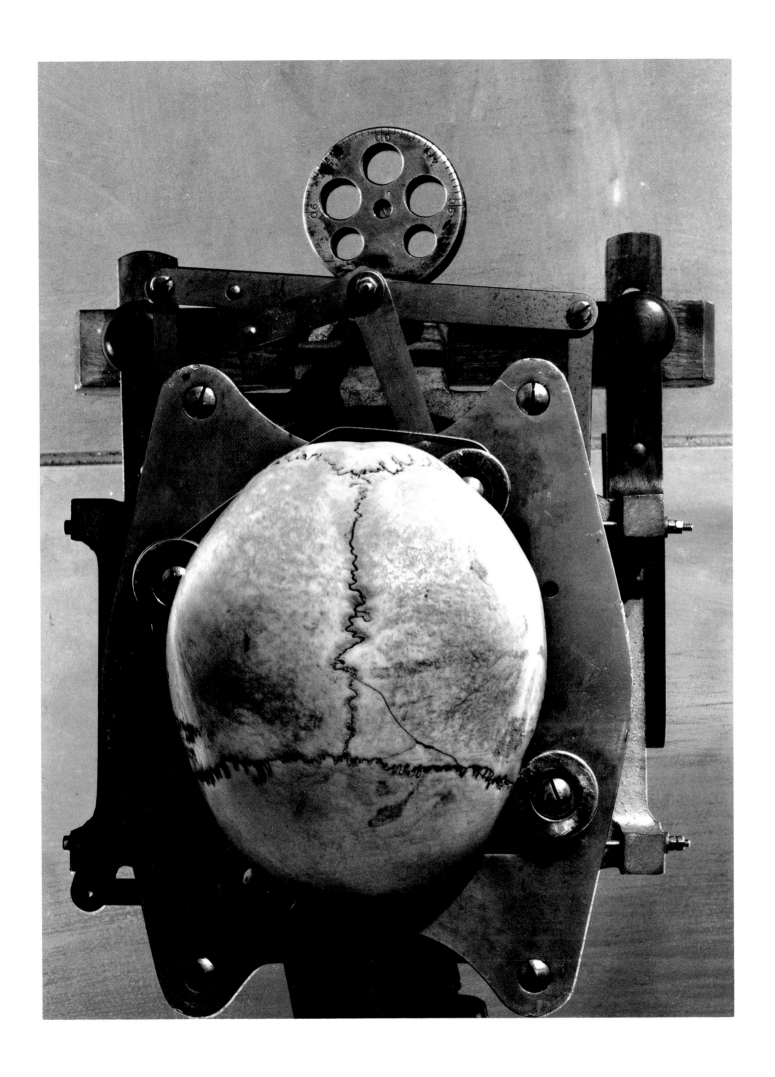

Plate 13. *Schädelmaschine (Skull Machine),* from *Erinnerungsspur (Memory's Trace),* 1977–79

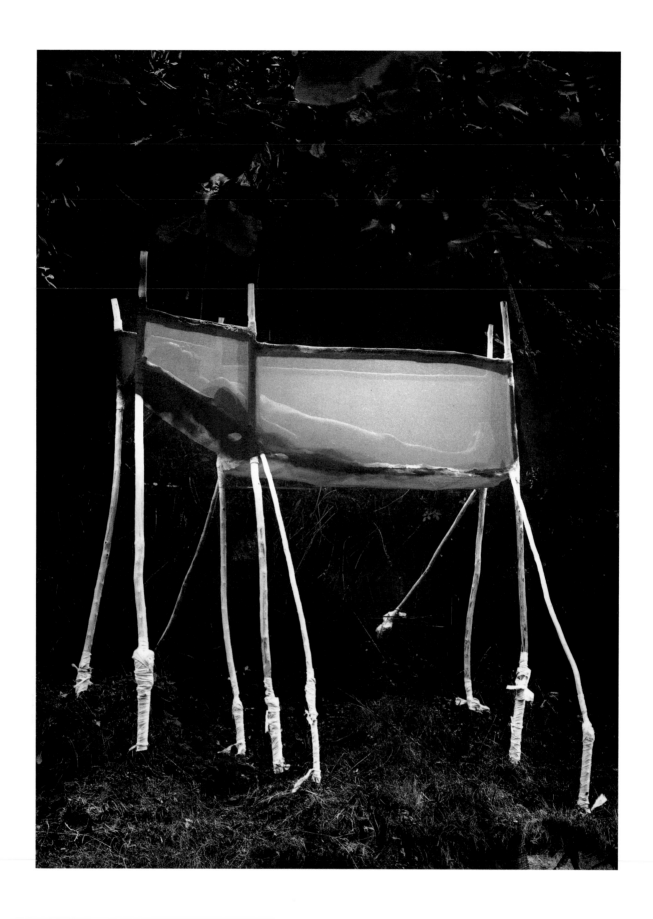

Plate 14. *Membranobjekt (Membrane Object)*, from *Erinnerungsspur (Memory's Trace)*, 1977–79

Plate 15. *Membranobjekt (Membrane Object), from Erinnerungsspur (Memory's Trace)*, 1977–79

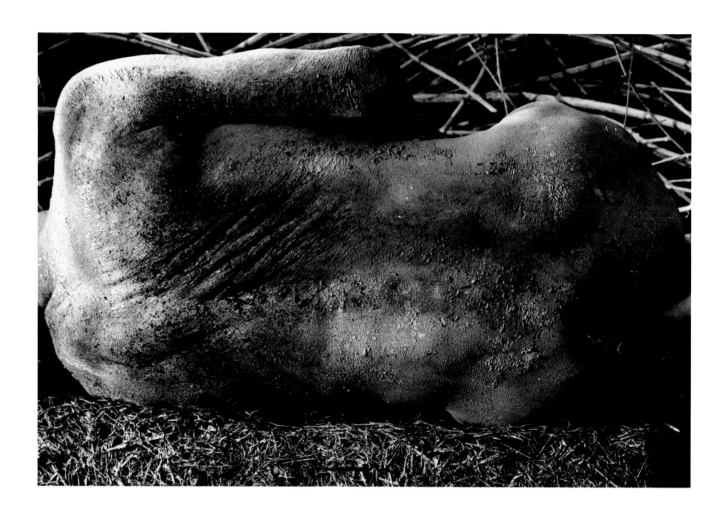

Plate 16. *Unter dem Dornenbusch (Under the Thornbush)*, from *Erinnerungsspur (Memory's Trace)*, 1977–79

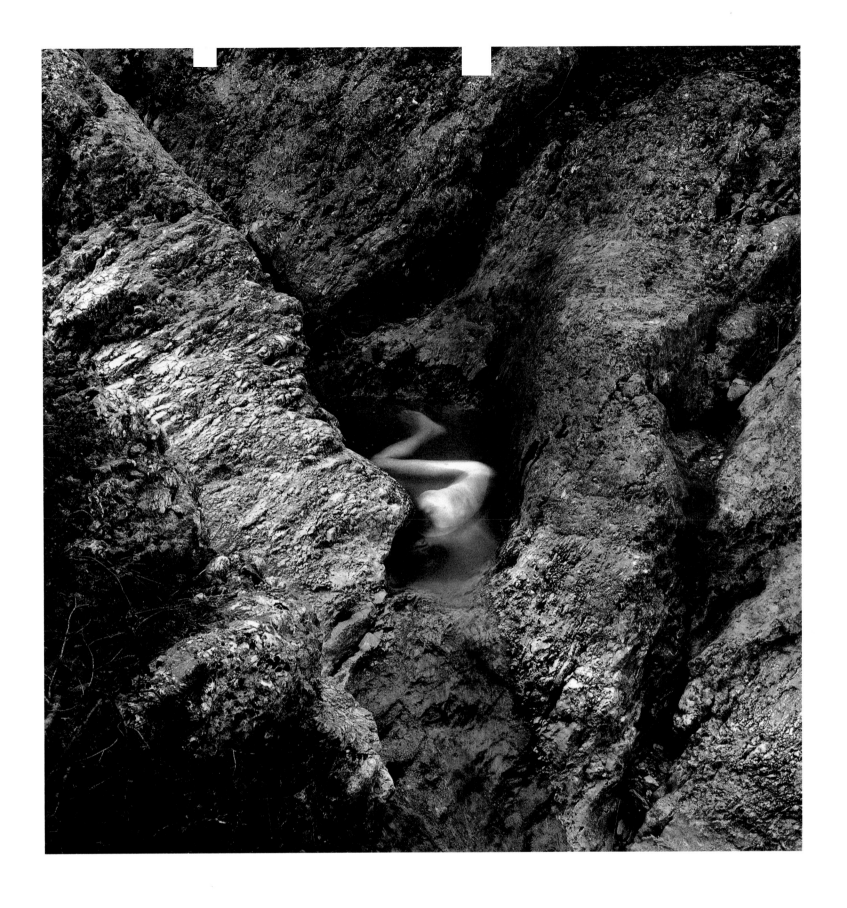

Plate 25. *Die Quelle (The Spring)*, from *Tableau Oppedette* (for Marguerite Duras), 1980

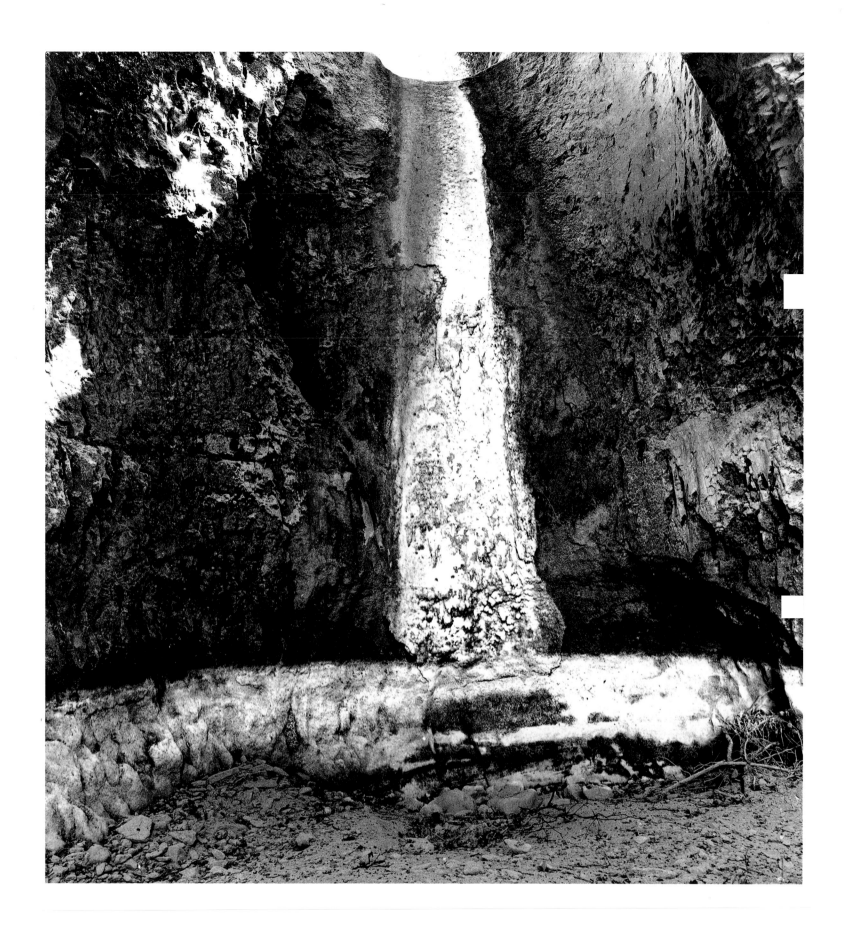

Plate 26. From *Tableau Oppedette* (for Marguerite Duras), 1980

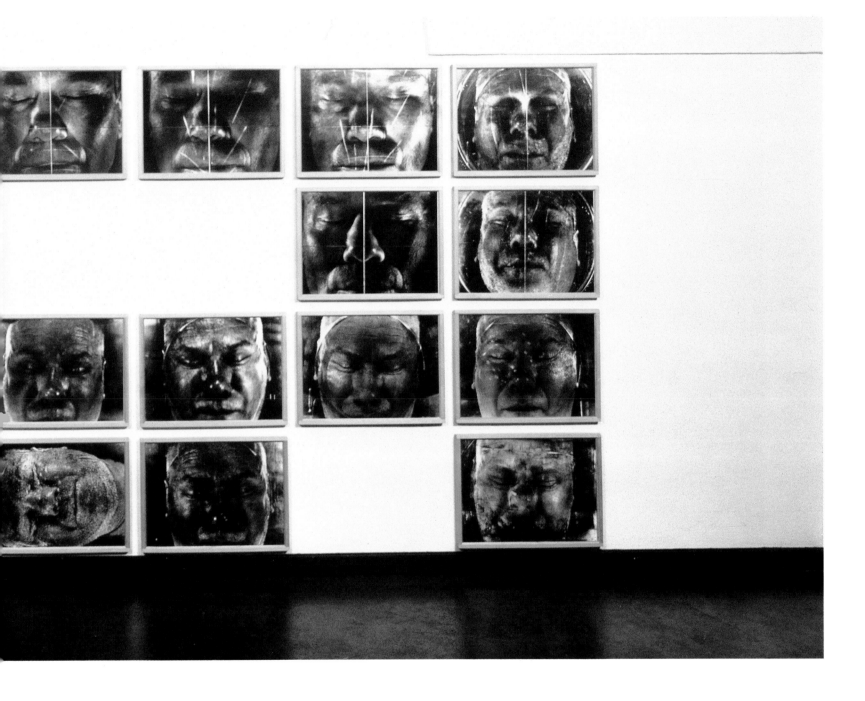

Plate 30. *Komplementärer Raum II (Complementary Space II)*, 1988–89

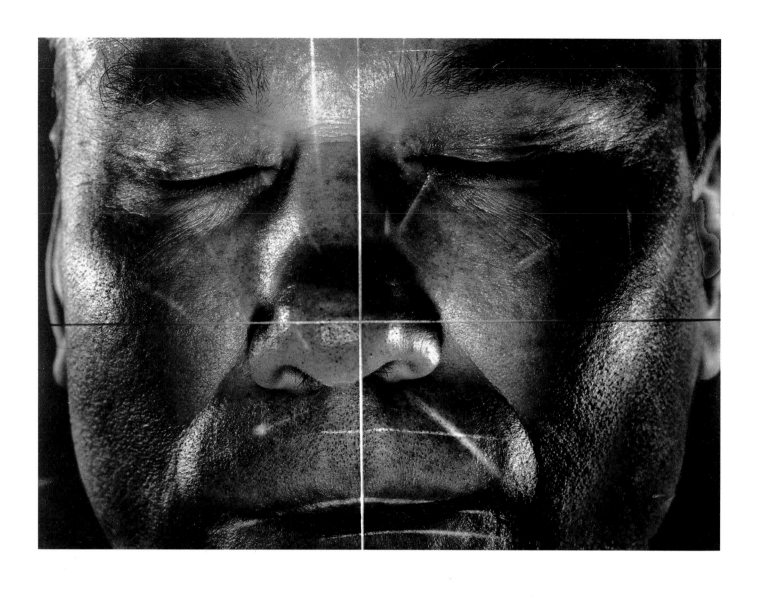

Plate 31. From *Komplementärer Raum II (Complementary Space II)*, 1988–89

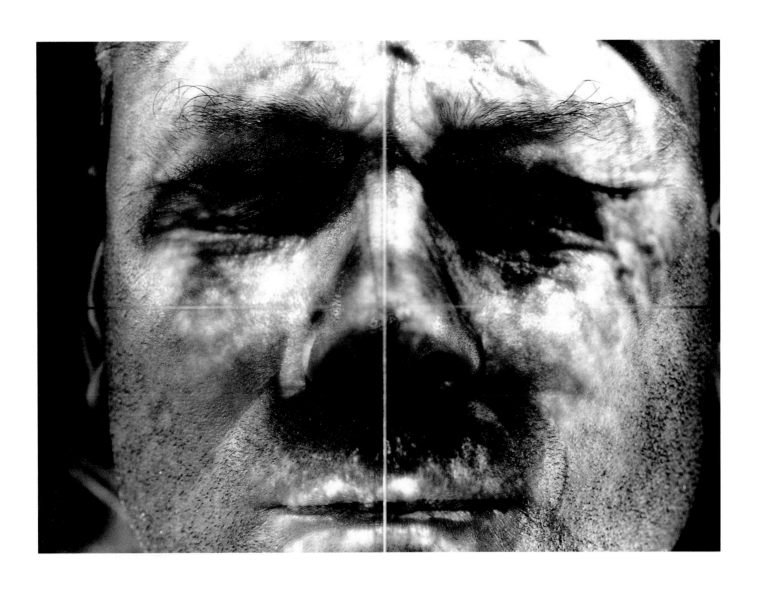

Plate 32. From *Komplementärer Raum II (Complementary Space II)*, 1988–89

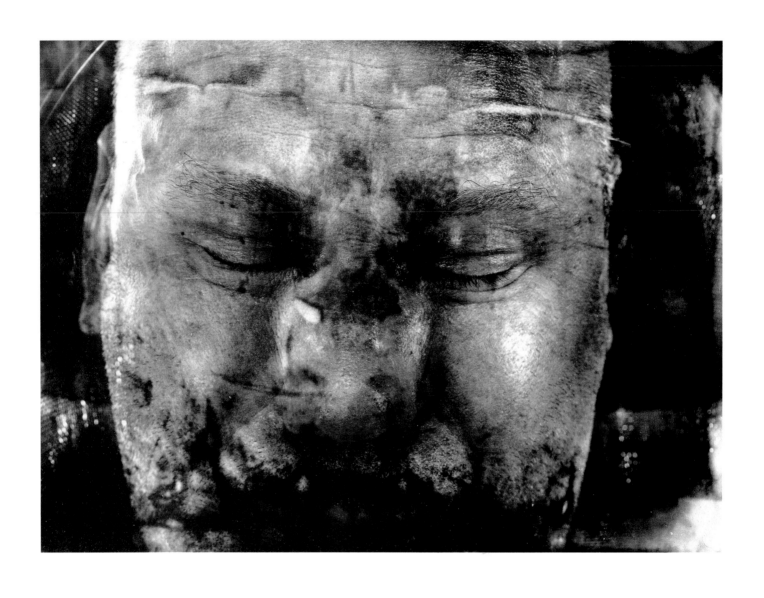

Plate 33. From *Komplementärer Raum II (Complementary Space II)*, 1988–89

Tableau Space

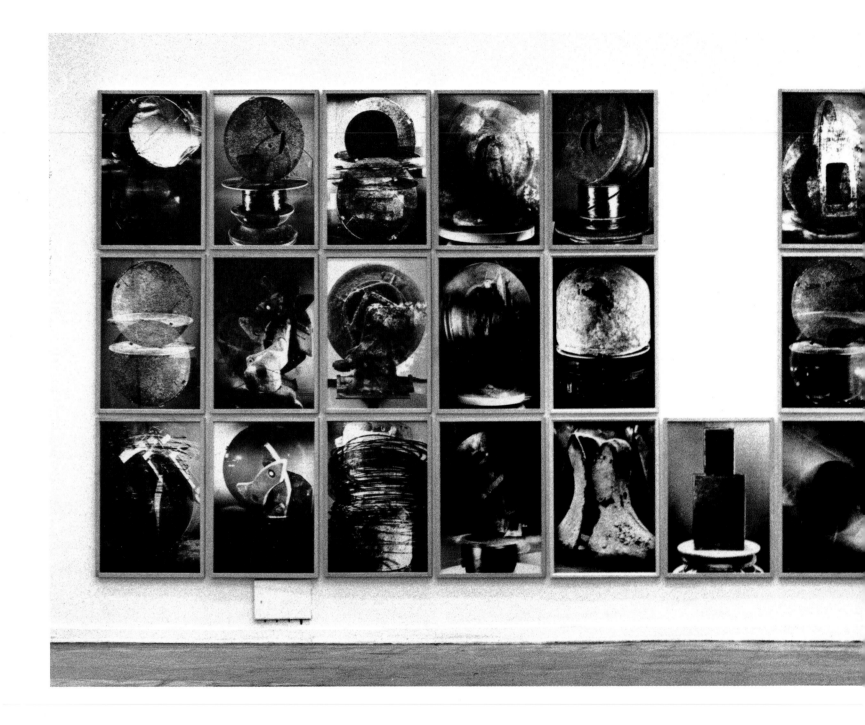

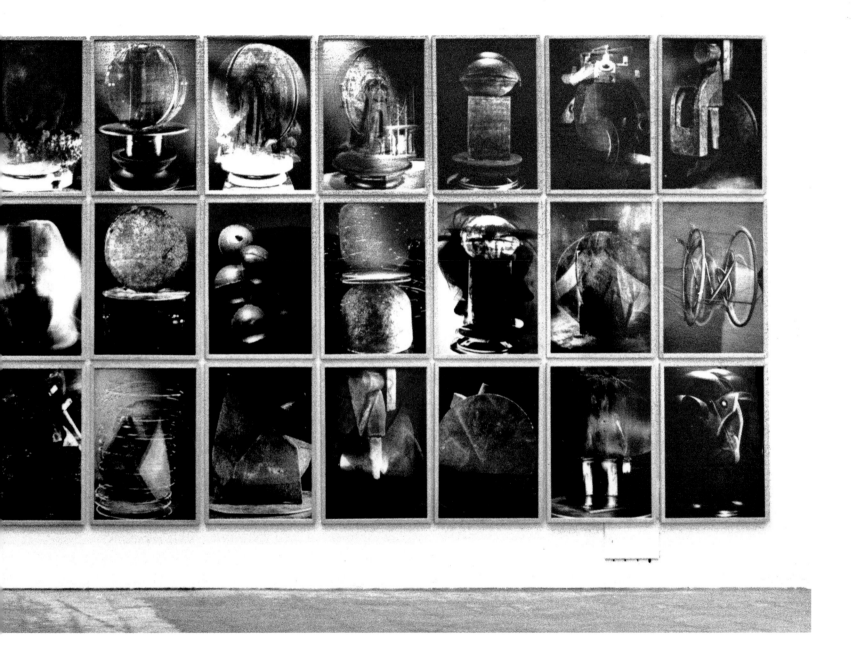

Plate 34. *Tableau Space (Space Tableau)*, 1989–90

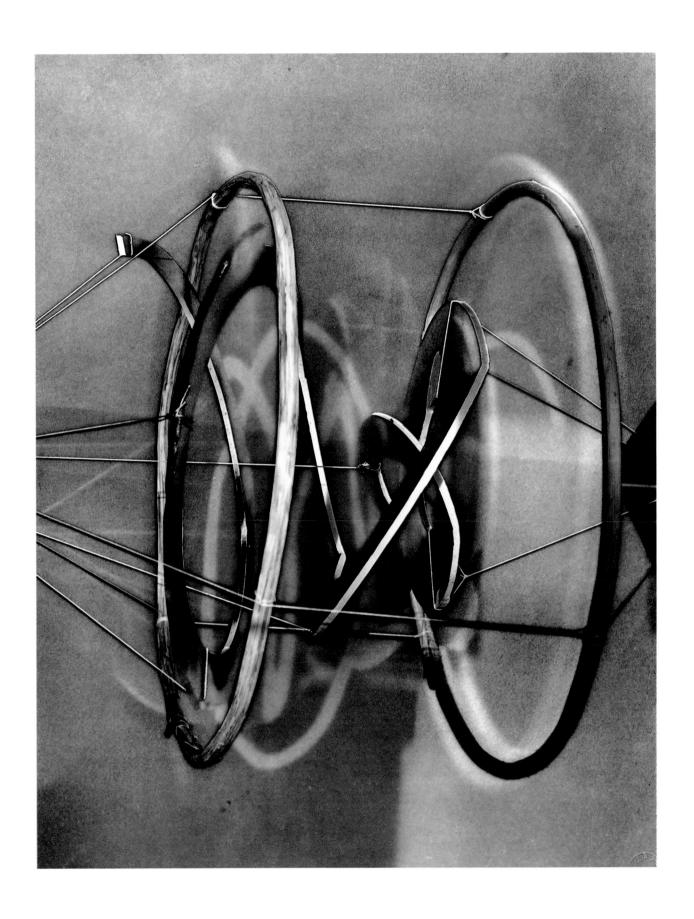

Plate 35. From *Tableau Space (Space Tableau)*, 1989–90

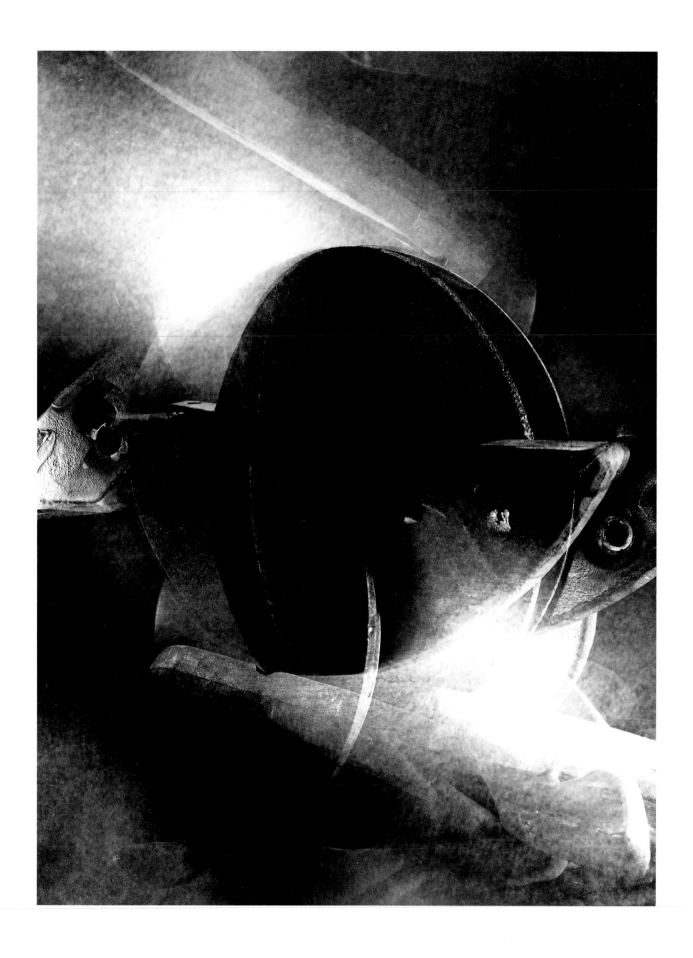

Plate 36. From *Tableau Space (Space Tableau)*, 1989–90

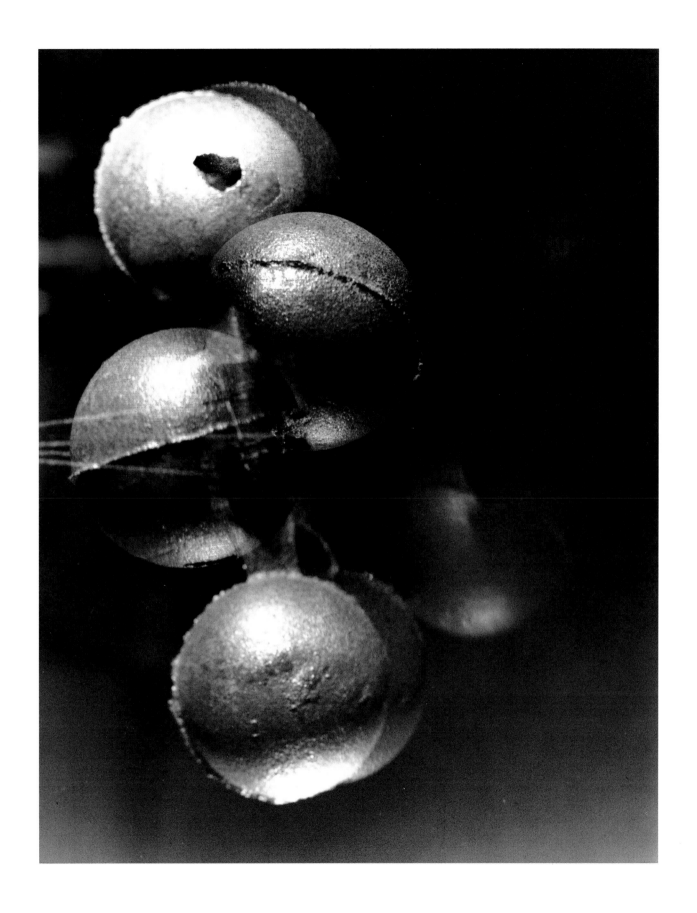

Plate 37. From *Tableau Space (Space Tableau)*, 1989–90

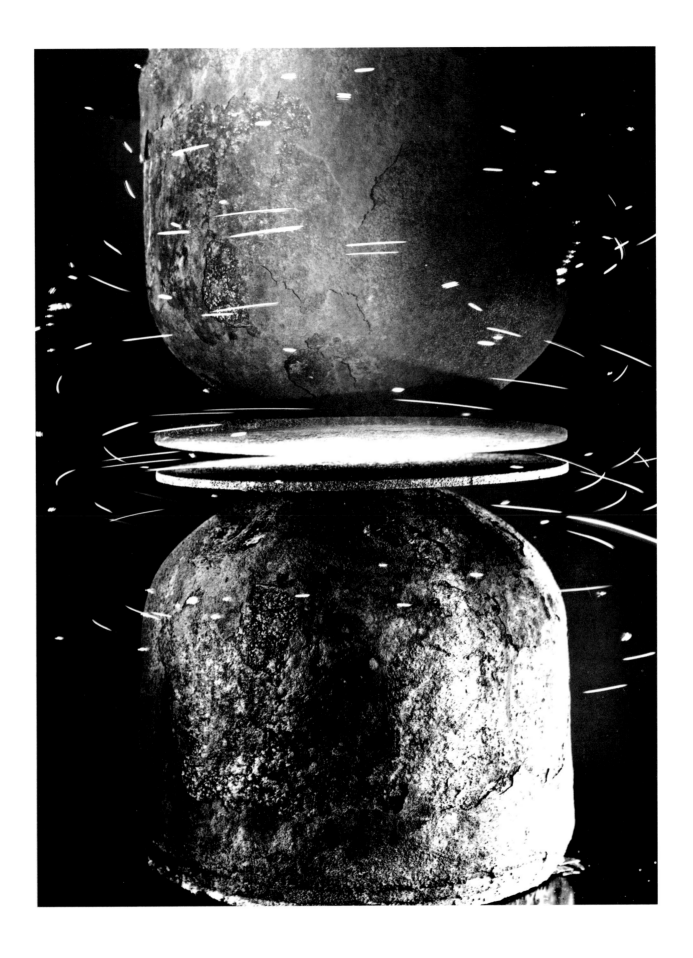

Plate 38. From *Tableau Space (Space Tableau)*, 1989—90

Die Schatten erinnern an nichts II

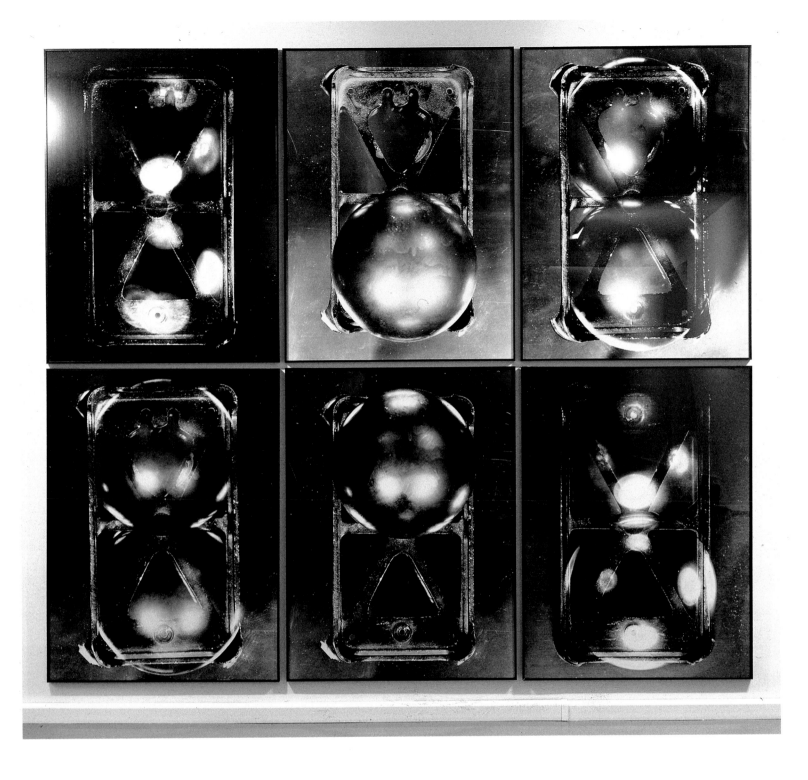

Plate 39. *Die Schatten erinnern an nichts II (The Shadows are Reminiscent of Nothing II)*, 1991

Das Feld

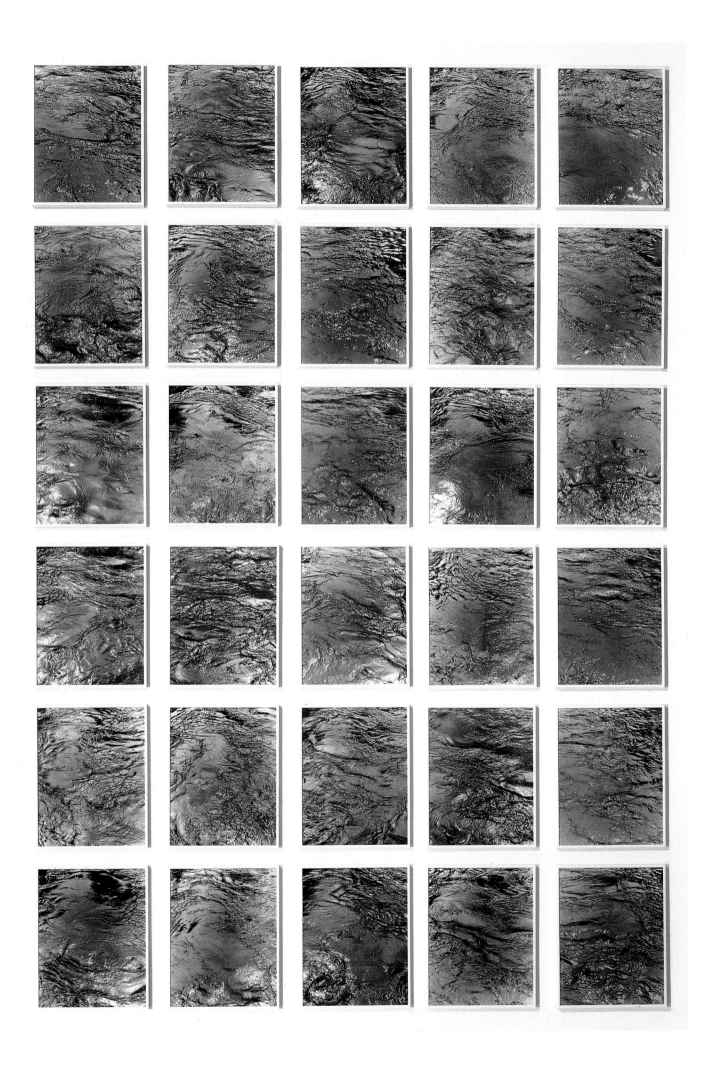

Plate 40. *Das Feld (The Field)*, 1991

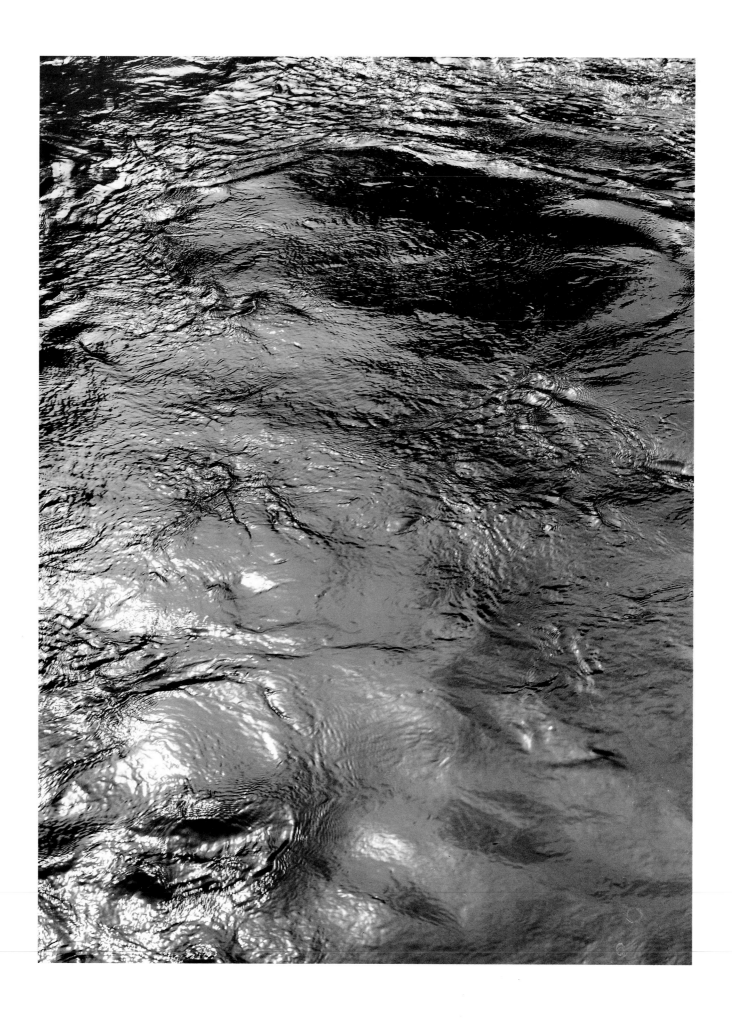

Plate 41. From *Das Feld (The Field)*, 1991

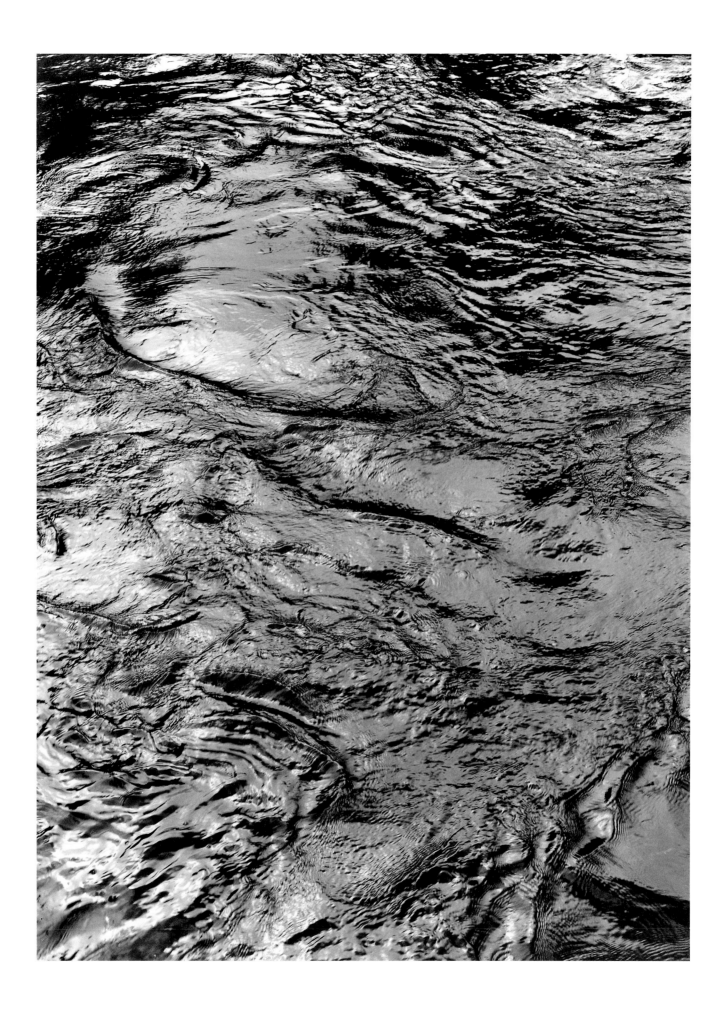

Plate 42. From *Das Feld (The Field)*, 1991

Kreuzweg

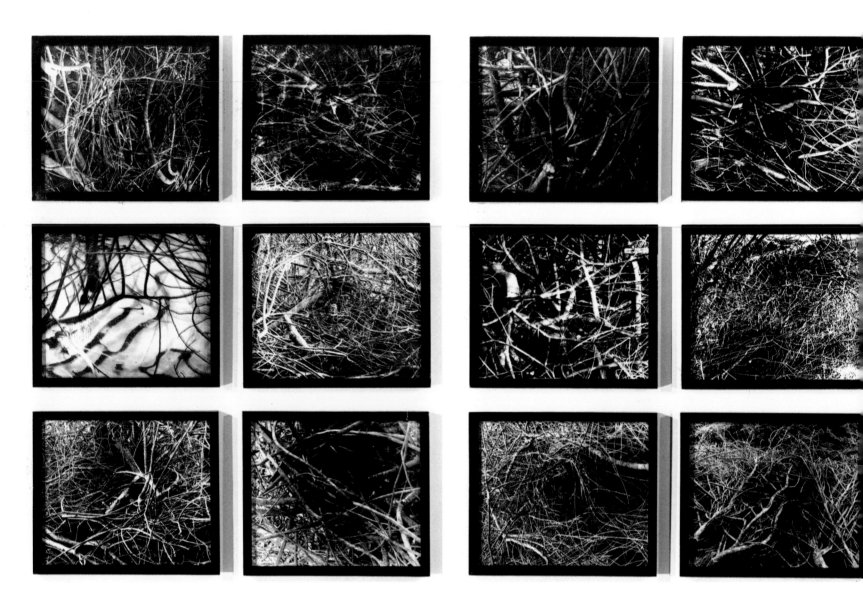

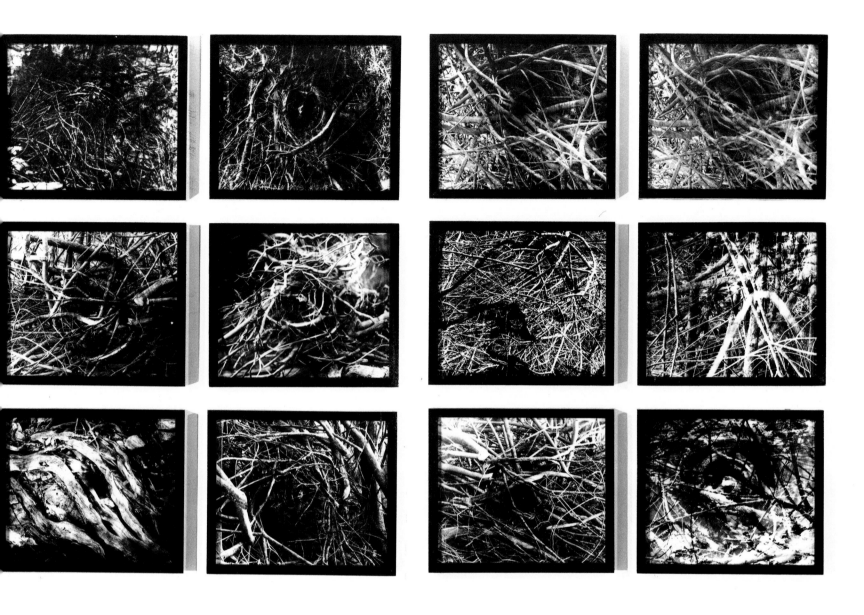

Plate 43. *Kreuzweg (Crossroad)*, 1993

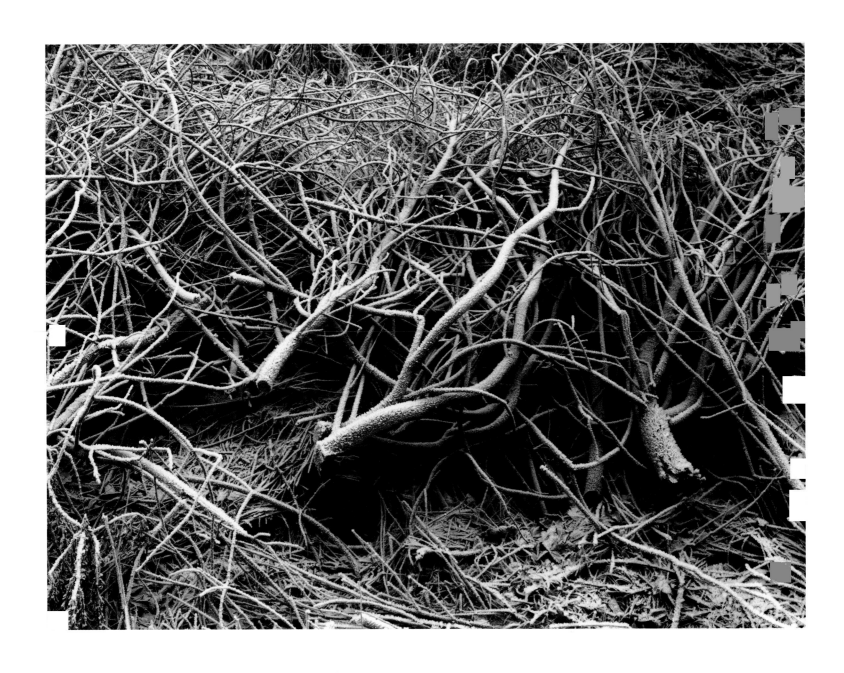

Plate 44. From *Kreuzweg (Crossroad)*, 1993

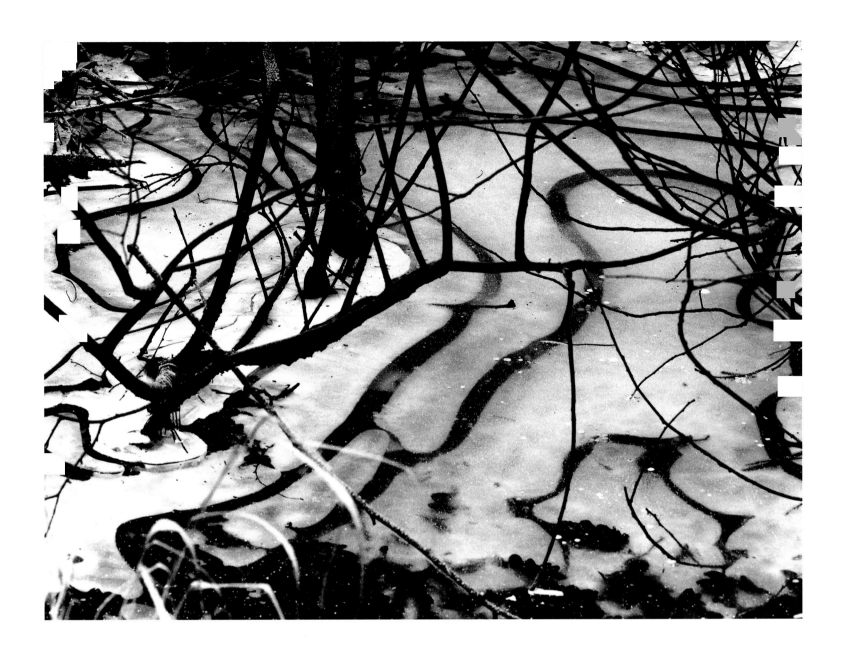

Plate 45. From *Kreuzweg (Crossroad)*, 1993

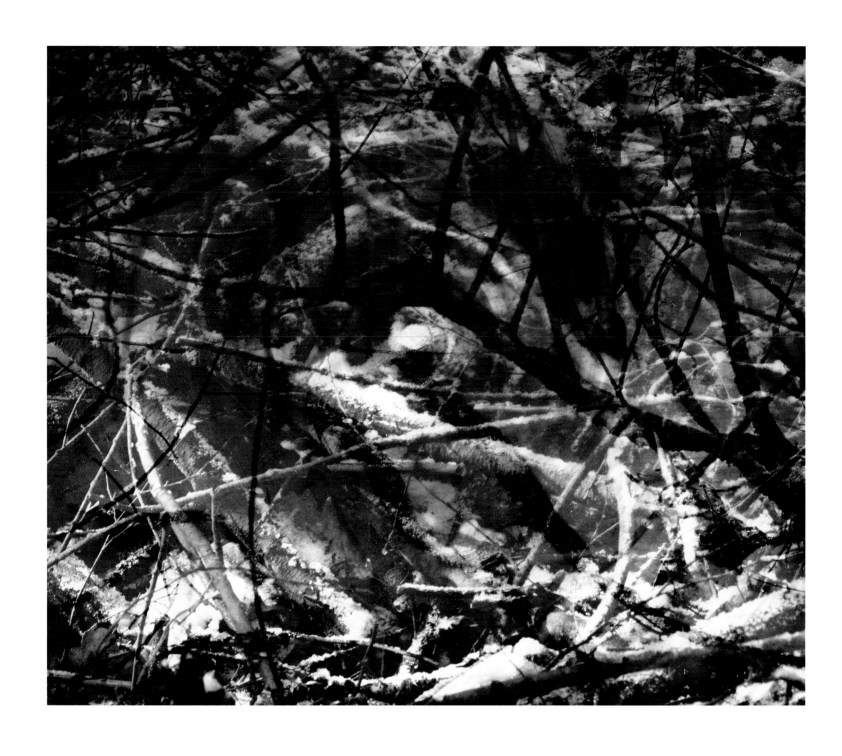

Plate 46. From *Kreuzweg (Crossroad)*, 1993

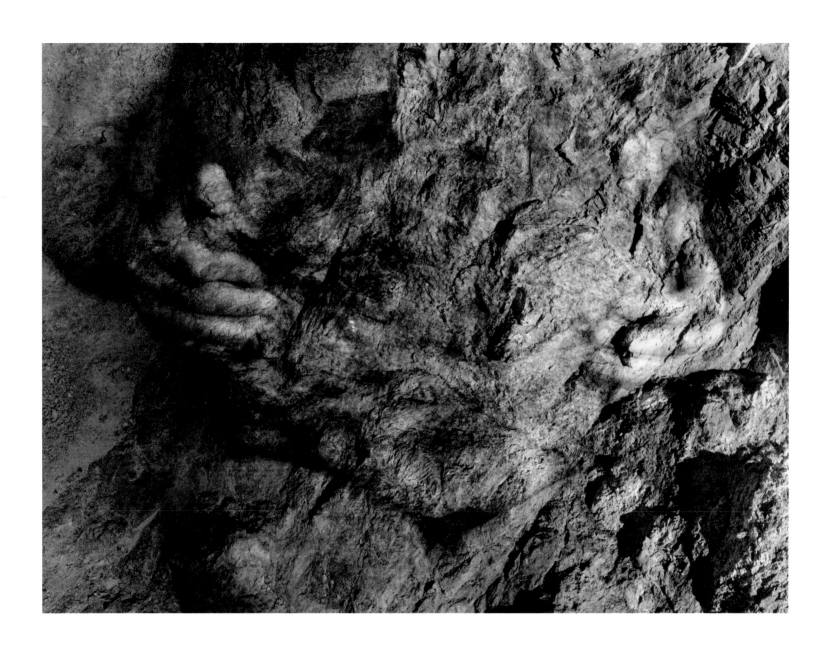

Plate 49. From *Steinfeld (Stone Field)*, 1994

Documentation

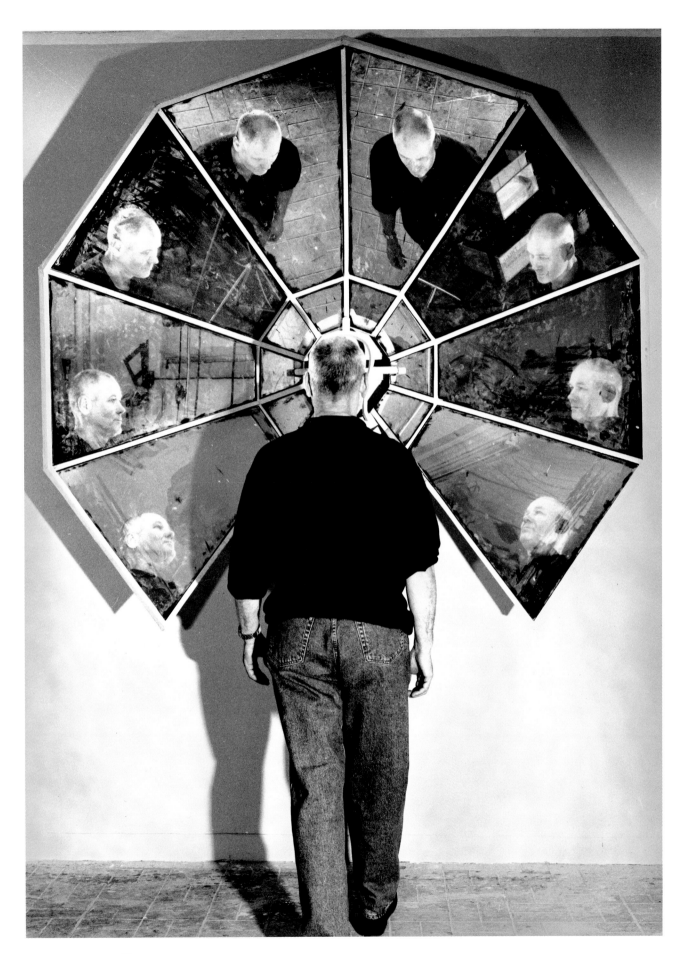

Figure 28.
Dieter Appelt in his studio
with *Spiegelfächerobjekt III
(Mirror Fan Object III)*, 1994
Photo by Claus H. Hartmann

Chronology

1935
Dieter Appelt is born March 3 in Niemegk, Germany. Months later, Appelt's family moves to Mühlenbeck.

1939
Appelt's father, an artist, dies and leaves behind cameras. World War II begins.

1945
In April, a battle between the German army and the Russian and American armies takes place near Appelt's family grounds. In May, World War II ends. East Germany becomes a separate state.

1954–1958
Studies music at the Mendelssohn Bartholdy Akademie, Leipzig. Develops strong interest in the compositions of Arnold Schoenberg, Anton Webern, Alban Berg, and Leos Janácek. Introduced to Impressionist, Fauve, and Russian Constructivist art. Meets future wife, Hanna. Dieter and Hanna marry in 1958.

1959–1960
Birth of daughter Giulietta in 1959. Months later, in October, Appelts leave East Germany and settle in West Berlin. Appelt renews studies at the Hochschule der Musik (Academy of Music), Berlin. Meets German experimental photographer Heinz Hajek-Halke. In addition to music classes, studies experimental photography and art at the Hochschule für bildende Künste (Academy of Fine Arts), Berlin, under Hajek-Halke's supervision. Student and teacher become friends.

Führerbunker

Figure 29.
Zahlensystem der Massai (Number System of the Masai), 1977

1961–1970
Birth of son Igor in 1961. Passes music exam and receives diploma. Is engaged by Berlin's opera company, the Deutsche Oper Berlin. Studies fine art at the Hochschule für bildende Künste until 1964. Experiments in painting, sculpture, etching, and photography.

1970
Travels to Japan with the Deutsche Oper Berlin to perform Arnold Schoenberg's *Moses und Aron*. Spends four months in Tokyo, Osaka, Kyoto, and Nara.

1971–1975
Continues working in photography, painting, sculpture, and etching. First art exhibition at the Deutsche Oper Berlin in 1974.

Selbstportraits (Self-Portraits). Photographic works 1973, monograph 1975

1976
Travels to Monte Isola, Italy, where Appelt makes the first *Hanging*. The image is a breakthrough and the beginning of a concentrated period of photographic work.

*Monte Isola.** Photographic works, monograph
 *Erste Hängung (First Hanging)**
 *Verlassenes Bauernhaus (Abandoned Farmhouse)**

1977–1979
Travels to Italy. Spends three years on *Erinnerungsspur (Memory's Trace)*, which contains several independently titled works. In 1979, leaves the Deutsche Oper Berlin to concentrate exclusively on visual arts.

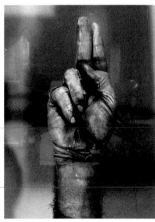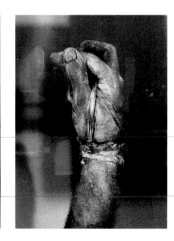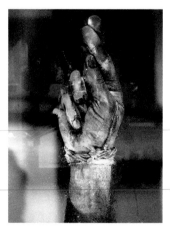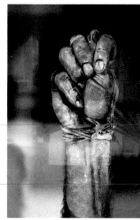

Erinnerungsspur (Memory's Trace), 1977–79. * Photographic works, monograph 1979

 Schneeloch (Hole in the Snow) *
 Membranobjekt (Membrane Object) *
 Unter dem Dornenbusch (Under the Thornbush) *
 Kopfholz (Headrest) *
 Schädelmaschine (Skull Machine) *
 Die Befreiung der Finger (Liberation of the Fingers) *
Moorbegehung (Crossing the Moor), 1977 *
Der Fleck auf dem Spiegel, den der Atemhauch schafft (The Mark on the Mirror Breathing Makes), 1977
Zahlensystem der Massai (Number System of the Masai), 1977
Spiegelfächer I (Mirror Fan I), 1977
Der Augenturm (Eye Tower) 1977. * Photographic works, monograph 1977
Die Symmetrie des Schädels (Symmetry of the Skull), 1977. ** *Aktion* performed at Galerie Georg Nothelfer, Berlin; monograph 1977.
Black Box. ** *Aktion* performed at Galerie Marzona, Düsseldorf, in 1978, at Hamburger Kunstverein, Hamburg, in 1979; *Symposium International d'Art Performance,* Lyons in 1980; and *ARS 83*, Ateneumin Taidemuseo, Helsinki, 1983.

1980
Summer in Oppedette, Haute Provence, France, where he performs *Flügelaktion* and *Haus in Oppedette* in canyon of Oppedette.

Autoportraits (Self-Portraits)
Flügelaktion (Wing Aktion) *
Haus in Oppedette (House in Oppedette) *
La Place des Pierres (Place of the Stones) *
Tableau Oppedette. * Photographic works, monograph 1981

1981
Travels to Italy, Mexico, and France.

Carnac
Ezra Pound *
Haus des Fausto (Fausto's House)
Tagundnachtgleiche (Equinox) *
Spur des Quetzalcóatl (Quetzalcóatl's Trace). * Photographic works, film
Image de la Vie et de la Mort (Image of Life and Death). ** Film, photographic work; *aktion* performed in 1982 at Künstlerhaus Bethanien, Berlin; Sara Hilden Art Museum, Tampere, Finland; and Musée d'Art et d'Histoire, Geneva

1982
Summer in Italy. Appointed head of department for film, video, and photography at the Hochschule für bildende Künste, Berlin.

Noch einmal Tage liebes Augenlicht (Another day, dear light of my eyes) *
Autoportraits (Self-Portraits)
Pitigliano. Photographic works, monograph 1983
Ganz-Gesicht (Whole Face). Photographic works, film 1982–83

1983
Travels to Italy.

Übertragung einer Bewegung (Transcription of a Movement). First large-scale multiple tableau
Sorano. Photographic works, film, monograph

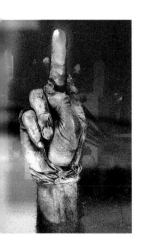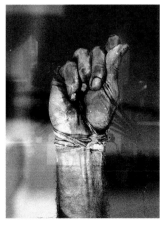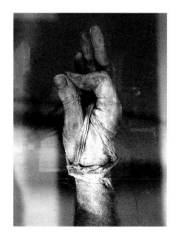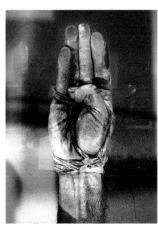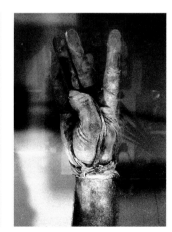

Figure 30.
Mainetower Model II, 1992
Wood, linen, and polymer
100 x 40 x 40 cm

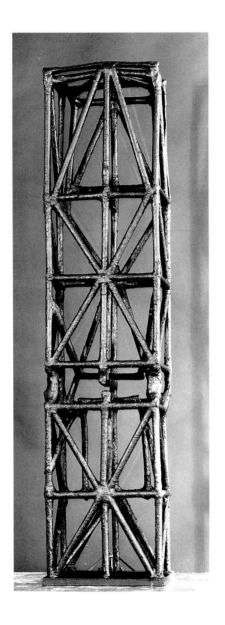

1984
Summer in Italy.

Double Take: Hände (Double Take: Hands)
Double Take: Portraits
Die Präsenz der Dinge in der Zeit (The Presence of Things in Time). Photographic works, monograph 1985
Bethanien. Photographic works, monographs 1984 and 1991
Museum der Sprachen (Museum of Languages). Photographic works by Dieter and Hanna Appelt, Monograph

1985
Summer in Italy. Begins investigating platinum techniques.

1986
Summer in Italy.

*Komplementärer Raum I (Complementary Space I)**
San Giacomo

1987
Builds mechanical device for objects to rotate before camera.

Canto I
Waldungen: Partitur zur Waldrandabhörung (Forests: Score for Listening to the Forest). Photographic work
Waldrandabhörung (Listening to the Forest). Digital film and video

1988–1990
Curates exhibition, *"Zwischen Schwarz und Weiß"* (*"Between Black and White"*) for the Neuer Berliner Kunstverein, Berlin.

Hund (Dog), 1989
Komplementärer Raum II (Complementary Space II),
1988–89
Tableau Space (Space Tableau), 1989–90

1991
Travels to Austria, Italy, Germany, and France looking for a river to photograph for *Das Feld.*

Die Schatten erinnern an nichts I (The Shadows Are Reminiscent of Nothing I)
Das Feld (The Field). Photographic works, monograph
Die Schatten erinnern an nichts II (The Shadows Are Reminiscent of Nothing II). Photographic works, monograph
Uranus. Photographic works, monograph
Canto II

1992
Travels to Maine, United States.

Vortex
Sakyamuni
Mainetower Models I–III.
Denkmal für die ermordeten Reichstagsabgeordneten (Monument for the Murdered Parliamentarians). Sculpture on Berlin Reichstag grounds
Siemens Fotoprojekt #17. Photographic works, monograph
Mainetower. Sculpture on island in Arrowsic, Maine,
1992–93
Membranobjekt (Membrane Object), from *Erinnerungsspur (Memory's Trace),* 1977–79/1992

Figure 31.
Zirkulationsfeld (Circulation Field), 1993

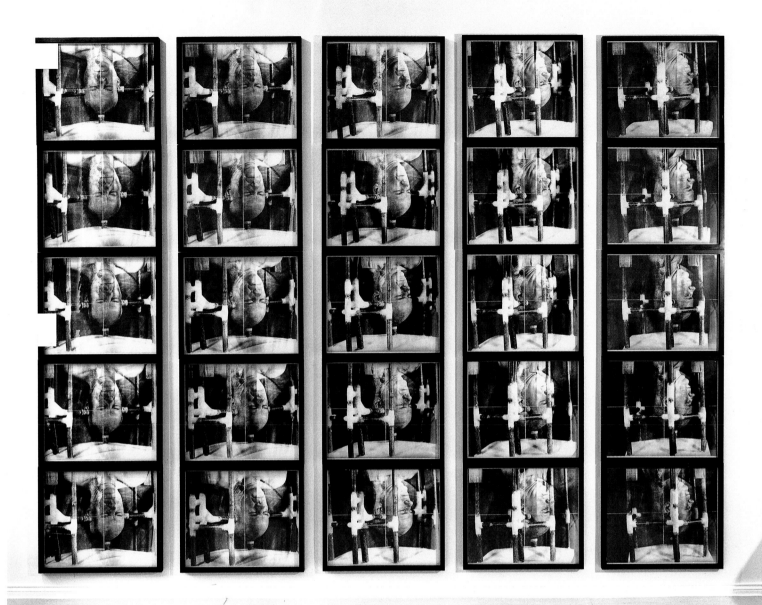

1993
Travels to Maine, United States; Vancouver, Canada; Italy; and Southern Germany.

Kreuzweg (Crossroad)
Mécano 1
Mécano 2
Zirkulationsfeld (Circulation Field)

1994
Travels to Gargnano, Italy, for limestone to use in *Steinfeld*.

Steinfeld (Stone Field). Photographic works, objects
Spiegelfächer II (Mirror Fan II). Photographic works 1977/1994
Waldungen: Partitur zur Waldrandabhörung (Forests: Score for Listening to the Forest), 1987/1994

*Aktion performed solely for the camera
**Aktion performed as a public event before a live audience

Catalogue of the Exhibition

1
Führerbunker, 1959–60
Gelatin silver print
34.2 x 23.9 cm
(Figure 2)

2
Selbstportraits (Self-Portraits), 1973
Gold-toned gelatin silver prints
Sixteen photographs, each 18 x 18 cm
(Figure 5)

3
Selbstportraits (Self-Portraits), 1973
Gold-toned gelatin silver prints
Sixteen photographs, each 18 x 18 cm
(Figure 6)

4
Erste Hängung (First Hanging),
from *Monte Isola*, 1976
Gelatin silver print
50 x 40 cm
(Plate 1)

5
From *Monte Isola*, 1976
Gelatin silver print
50 x 60 cm
(Plate 2)

6
From *Monte Isola*, 1976
Gelatin silver print
40 x 30 cm
(Plate 3)

7
From *Monte Isola*, 1976
Gelatin silver print
50 x 40 cm
(Plate 4)

8
From *Moorbegehung (Crossing the Moor)*, 1977
Gelatin silver print
50 x 60 cm
Lent by Sander Gallery, New York
(Figure 7)

9
From *Moorbegehung (Crossing the Moor)*, 1977
Gelatin silver print
60 x 50 cm
Lent by Sander Gallery, New York

10
From *Moorbegehung (Crossing the Moor)*, 1977
Gelatin silver print
60 x 50 cm
Lent by Sander Gallery, New York

11
From *Moorbegehung (Crossing the Moor)*, 1977
Gelatin silver print
60 x 50 cm
Lent by Sander Gallery, New York

12
From *Moorbegehung (Crossing the Moor)*, 1977
Gelatin silver print
60 x 50 cm
Lent by Sander Gallery, New York

13
From *Moorbegehung (Crossing the Moor)*, 1977
Gelatin silver print
60 x 50 cm
Lent by Sander Gallery, New York

14
*Ich will mich nicht über die Bäume erheben
(I don't want to elevate myself above the trees)*,
from *Moorbegehung (Crossing the Moor)*, 1977
Gelatin silver print
60 x 50 cm
Lent by Sander Gallery, New York
(Figure 8)

15
From *Der Augenturm (Eye Tower)*, 1977
Gelatin silver print
60 x 50 cm
Lent by Sander Gallery, New York
(Plate 5)

16
From *Der Augenturm (Eye Tower)*, 1977
Gelatin silver prints
Four photographs, each 50 x 50 cm
Lent by Sander Gallery, New York
(Plates 6—9)

17
From *Der Augenturm (Eye Tower)*, 1977
Gelatin silver print
60 x 50 cm
Lent by Sander Gallery, New York

18
From *Der Augenturm (Eye Tower)*, 1977
Gelatin silver print
60 x 50 cm
Lent by Sander Gallery, New York

19
Holzkrone (Wooden Crown), from *Der Augenturm
(Eye Tower)*, 1977
Wood, twine, and glue
110 x 120 x 10 cm
Lent by Jürgen Hermeyer, Munich

20
Sketch for *Die Symmetrie des Schädels
(Symmetry of the Skull)*, 1977
Gelatin silver prints
Five photographs mounted on 20 x 80 cm board
Lent by Jürgen Hermeyer, Munich

21
*Zahlensystem der Massai
(Number System of the Masai)*, 1977
Gelatin silver prints
Ten photographs, each 40 x 30 cm
Lent by Hanna Appelt, Berlin
(Figure 29)

22
Schneeloch (Hole in the Snow), from *Erinnerungsspur
(Memory's Trace)*, 1977—79
Gelatin silver print
50 x 60 cm
(Plate 10)

23
Kopfholz (Headrest), from *Erinnerungsspur
(Memory's Trace)*, 1977—79
Gelatin silver print
40 x 30 cm
(Plate 11)

24
From *Erinnerungsspur (Memory's Trace)*, 1977—79
Gelatin silver print
40 x 30 cm
(Plate 12)

25
Schädelmaschine (Skull Machine), from *Erinnerungsspur
(Memory's Trace)*, 1977—79
Gelatin silver print
60 x 50 cm
Lent by Hanna Appelt, Berlin
(Plate 13)

26
Membranobjekt (Membrane Object), from *Erinnerungsspur
(Memory's Trace)*, 1977—79
Gelatin silver print
40 x 30 cm
(Plate 14)

27
Membranobjekt (Membrane Object), from *Erinnerungsspur
(Memory's Trace)*, 1977—79
Gelatin silver print
60 x 50 cm
(Plate 15)

28
Unter dem Dornenbusch (Under the Thornbush),
from *Erinnerungsspur (Memory's Trace)*, 1977—79
Gelatin silver print
50 x 60 cm
(Plate 16)

29
From *Erinnerungsspur (Memory's Trace)*, 1977—79
Gelatin silver print
40 x 30 cm
Lent by Galerie Springer, Berlin
(Plate 17)

30
Die Befreiung der Finger (Liberation of the Fingers),
from *Erinnerungsspur (Memory's Trace)*, 1977—79
Gelatin silver prints
Six photographs, each 40 x 30 cm
Lent by Galerie Kicken, Cologne
(Plates 18—23)

31
From *Erinnerungsspur (Memory's Trace)*, 1977—79
Gelatin silver print
50 x 50 cm

32
From *Erinnerungsspur (Memory's Trace)*, 1977–79
Gelatin silver print
50 x 50 cm

33
From *Erinnerungsspur (Memory's Trace)*, 1977–79
Gelatin silver print
40 x 30 cm

34
From *Erinnerungsspur (Memory's Trace)*, 1977–79
Gelatin silver print
60 x 50 cm

35
Kopfholzobjekt (Headrest Object), from *Erinnerungsspur
(Memory's Trace)*, 1977–79
Wood and linen
80 x 30 x 30 cm
Lent by Hanna Appelt, Berlin

36
*Der Fleck auf dem Spiegel, den der Atemhauch schafft
(The Mark on the Mirror Breathing Makes)*, 1977
Gelatin silver print
30 x 40 cm
Lent by Galerie Springer, Berlin
(Plate 24)

37
Die Quelle (The Spring), from *Tableau Oppedette*, 1980
Gelatin silver print
50 x 50 cm
Lent by Peter and Ursula Raue, Berlin
(Plate 25)

38
From *Tableau Oppedette*, 1980
Gelatin silver print
50 x 50 cm
Lent by Peter and Ursula Raue, Berlin
(Plate 26)

39
From *Tableau Oppedette*, 1980
Gelatin silver print
50 x 50 cm
Lent by Peter and Ursula Raue, Berlin
(Plate 27)

40
From *Tableau Oppedette*, 1980
Gelatin silver print
50 x 50 cm
Lent by Peter and Ursula Raue, Berlin

41
From *Tableau Oppedette*, 1980
Gelatin silver print
50 x 50 cm
Lent by Peter and Ursula Raue, Berlin

42
Flügelobjekt (Wing Object), 1980
Wood, canvas, and twine
100 x 600 x 60 cm
Lent by Peter and Ursula Raue, Berlin

43
Haus in Oppedette (House in Oppedette), 1980
Gelatin silver prints; wood and canvas model
Five photographs, each 44 x 27 cm
Model, 76 x 152 x 66 cm
Lent by Manfred and Hanna Heiting, Amsterdam
(Figure 9)

44
From the sequence *Ezra Pound*, 1981
Gelatin silver print
35 x 28 cm
(Plate 28)

45
From the sequence *Ezra Pound*, 1981
Gelatin silver print
30 x 24 cm

46
From the sequence *Ezra Pound*, 1981
Gelatin silver print
30 x 24 cm

47
From the sequence *Ezra Pound*, 1981
Gelatin silver print
26 x 18 cm
(Figure 11)

48
Stills from the seventeen-minute, black-and-white
16mm film *Image de la Vie et de la Mort (Image of Life
and Death),* 1981
Gelatin silver prints
180 x 25 cm
Lent by Galerie Rudolf Kicken, Cologne
(Plate 29)

49
*Die Präsenz der Dinge in der Zeit (The Presence of Things
in Time),* 1984
Gelatin silver prints
Six photographs, each 12 x 18 cm
(Figure 17)

50
Canto I, 1987
Gelatin silver prints
Ten photographs, each 15 x 21.5 cm
Lent by Galerie Limmer, Freiburg
(Figure 15)

51
Canto II, 1991
Gelatin silver prints
Ten photographs, each 40 x 50 cm
Lent by Galerie Springer, Berlin

52
Double Take: Hände (Double Take: Hands), 1984
Gelatin silver prints
Five photographs, each 25 x 30 cm
Lent by Galerie Limmer, Freiburg

53
Pitigliano, 1982
Gelatin silver prints
Ten photographs, each 90 x 120 cm
Lent by Elisabeth-Schneider-Stiftung, Freiburg
(Figure 16)

54
*Übertragung einer Bewegung (Transcription of a
Movement),* 1983
Gelatin silver prints
One hundred sixty photographs, each 12 x 18 cm,
in four sections, each 150 x 85 cm
Lent by Galerie Limmer, Freiburg
(Figure 32)

55
Komplementärer Raum II (Complementary Space II),
1988–89
Gelatin silver prints
Thirty photographs, each 50 x 60 cm
Lent by Elisabeth-Schneider-Stiftung, Freiburg
(Plates 30–33)

56
Tableau Space (Space Tableau), 1989–90
Chromogenic color prints
Forty photographs, each 100 x 70 cm
Lent by Fonds Régional d'Art Contemporain,
Provence-Alpes-Côte D'Azur
(Plates 34–38)

57
*Die Schatten erinnern an nichts II (The Shadows Are
Reminiscent of Nothing II),* 1991
Gelatin silver prints
Six photographs, each 150 x 114 cm
Lent by Berlinische Galerie, Photographische
Sammlung, Berlin
(Plate 39)

58
Das Feld (The Field), 1991
Gelatin silver prints
Thirty photographs, each 50 x 40 cm
Lent by the Museum of Modern Art, New York
Joel and Anne Ehrenkranz Fund, John Parkinson III Fund,
and the Fellows of Photography Fund
(Plates 40–42)

59
Membranobjekt (Membrane Object), from *Erinnerungsspur
(Memory's Trace),* 1977–79/1992
Gelatin silver prints
Four photographs, each 60 x 50 cm
Lent by Joshua Smith, Washington, and Galerie Rudolf
Kicken, Cologne
(Figure 23)

60
Mainetower Model I, 1992
Wood and linen
100 x 40 x 40 cm
Lent by Galerie Rudolf Kicken, Cologne

Figure 32.
Übertragung einer
Bewegung
(Transcription of a
Movement), 1983

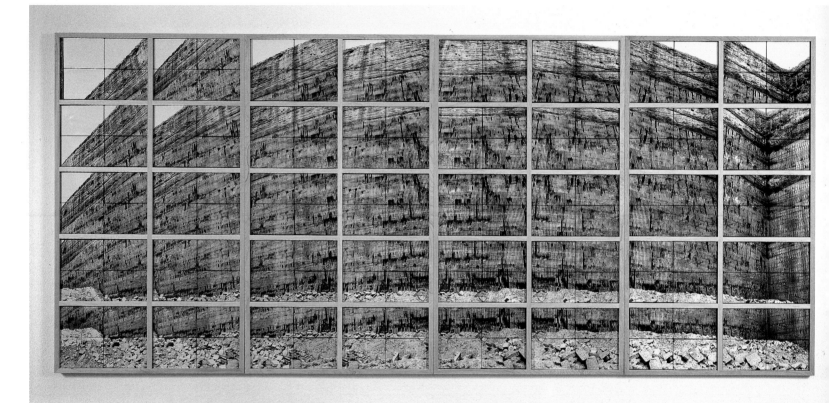

61
Mainetower, 1992−93
Gelatin silver print
60 x 50 cm
(Figure 22)

62
Kreuzweg (Crossroad), 1993
Gelatin silver prints
Twenty-four photographs, each 50 x 60 cm
Lent by Neue Galerie der Stadt, Linz
(Plates 43−46)

63
Zirkulationsfeld (Circulation Field), 1993
Gelatin silver prints
Twenty-five photographs, each 56.5 x 66.5 cm
Lent by Blondeau Fine Art Services, Geneva
(Figure 31)

64
Waldungen: Partitur zur Waldrandabhörung
(Forests: Score for Listening to the Forest), 1987/1994
Gelatin silver prints
Five hundred forty photographs, each 6 x 12 cm,
in ten sections, each 200 x 72 cm
Lent by Galerie Limmer, Freiburg
(Figure 18)

65
Steinfeld (Stone Field), 1994
Gelatin silver prints
Twenty-one photographs, each 50 x 60 cm
Lent by Galerie Limmer, Freiburg
(Plates 47−49)

66
Spiegelfächer II (Mirror Fan II), 1977/1994
Gelatin silver prints
Ten photographs, each 40 x 30 cm

67
Spiegelfächerobjekt I (Mirror Fan Object I), 1977
Found object: metal flashbulb reflector
10 x 10 x 4 cm
Lent by Hanna Appelt, Berlin

68
Spiegelfächerobjekt II (Mirror Fan Object II), 1993−94
Wood, canvas, and mirrors
60 x 60 x 40 cm
Lent by Hanna Appelt, Berlin

Selected Solo Exhibitions

1974
Berlin, Deutsche Oper Berlin

1977
Berlin, Galerie Georg Nothelfer
 (*Aktion: Die Symmetrie des Schädels*)

1978
Berlin, Galerie Petersen
Düsseldorf, Galerie Marzona (*Aktion: Black Box*)

1979
Berlin, Galerie Werner Kunze
Berlin, Neuer Berliner Kunstverein

1980
Bordeaux, Galerie Arpa
Düsseldorf, Galerie Marzona
Lyons, *Symposium International d'Art Performance*
 (*Aktion: Black Box*)

1981
Berlin, Neuer Berliner Kunstverein and Künstlerhaus
 Bethanien
Berlin, Galerie Springer
Geneva, Musée d'Art et d'Histoire (*Aktion: Black Box*)
Munich, Galerie Hermeyer
New York, Hyperion Press
Paris, Galerie Ufficio dell Arte Creatis

1982
Berlin, Künstlerhaus Bethanien
 (*Aktion: Image de la Vie et de la Mort*)
Berlin, Galerie Petersen
Bordeaux, Galerie Arpa
Helsinki, Amos Andersen Museum
Locarno, Galleria Flaviana
Tampere, Finland, Sara Hilden Art Museum
 (*Aktion: Image de la Vie et de la Mort*)

1983
Lausanne, Galerie Junod
Munich, Städtische Galerie im Lenbachhaus
Munich, Galerie Hermeyer

1984
Berlin, Künstlerhaus Bethanien

1985
Munich, Galerie Hermeyer
Rochester, International Museum of Photography
 at George Eastman House

1986
Amsterdam, Stedelijk Museum
Paris, Galerie 666
Paris, Goethe-Institut
Paris, Mois de la Photo, Prix special du Jury

1987
Basel, Galerie Photo-Art
Berlin, Ruine der Künste
Liège, Musée des Beaux-Arts

1988
Berlin, Galerie Nowald
Paris, Galerie Baudoin Lebon
Porto, Portugal, Casa de Serralves
Rotterdam, Galerie Perspektief

1989
Paris, Centre National de la Photographie,
Palais de Tokyo
Munich, Galerie Hermeyer

1990
Barcelona, Centre d'Art Santa Monica
Cologne, Galerie Kicken-Pauseback
Salzburg, Galerie Fotohof Salzburg

1991
Berlin, Galerie Springer
Freiburg, Galerie Limmer
Paris, Galerie Bouqueret et Lebon

1992
Cologne, Galerie Rudolf Kicken
Frankfurt, Springer & Winckler Galerie
Freiburg, Galerie Limmer
New York, P.P.O.W.
Vienna, Galerie Chobot

1994
New York, Sander Gallery

Selected Group Exhibitions

1977
Berlin, Nationalgalerie, and Neuer Berliner Kunstverein, *Kunstübermittlungsformen: Vom Tafelbild bis zum Happening*

1979
Hamburg, Hamburger Kunstverein, *Das veränderte Selbstverständnis von Künstlern: Eremit? Forscher? Sozialarbeiter? (Aktion: Black Box)*

1980
Arles, Rencontres Internationales de la Photographie

1981
Berlin, German Academic Exchange Service, *Berlin in Nizza*
Geneva, Musée Rath, *Aspect de l'Art d'Aujourd'hui*
Houston, Benteler Galleries Inc., *Photography Europe I*
Paris, Musée Nationale d'Art Moderne, Centre Georges Pompidou, *Autoportraits Photographiques 1898–1981*

1982
Geneva, Musée d'Art et d'Histoire *(Aktion: Image de la Vie et de la Mort)*
Nantes, Centre Culturel, *Suite, Série, Séquence*
Stockholm, Kulturhuset, *Käusla och Hardhet*

1983
Helsinki, Ateneumin Taidemuseo, *ARS 83 (Aktion: Black Box)*
Munich, Städtische Galerie im Lenbachhaus, *Todesbilder*
Quimper, Recontres d'Art, *Allemagne Années 1980*

1984
Paris, La Bibliothèque Nationale, *Récents Enrichissements*
Paris, Pavillon des Arts, *La Photographie Créative à travers les Collections Photographiques Contemporaines de la Bibliothèque Nationale*

1985
Berlin, Künstlerhaus Bethanien, *Umfeld Bethanien*
Berlin, Nationalgalerie, *Kunst in der Bundesrepublik Deutschland, 1945–1985*
Berlin, Staatliche Kunsthalle, *Elementarzeichen*
Lacock Abbey, Fox Talbot Museum of Photography, *The Window*
Lausanne, Musée Cantonal des Beaux-Arts, and Akademie der Künste, Berlin, *A l'Epoque de la Photographie (Autoportraits)*

1986
Berlin, Akademie der Künste, *Androgyn*
Metz, Musée pour la Photographie, and Centre National de la Photographie, Palais de Tokyo, Paris, *Théâtre des Réalités*

1987
Berlin, Akademie der Künste, *Waldungen: Die Deutschen und ihr Wald*
Cologne, Joseph-Habrich Kunsthalle, and Neuer Berliner Kunstverein, Berlin, *Zehn:Zehn*
London, National Portrait Gallery, *Staging the Self: Self-Portait Photography 1840–1980*
Madrid, Ayuntamiento de Madrid, Kodak S.A., *Autoretratto:Narcismo ó Provocación*
Tokyo, Hara Museum of Contemporary Art, *Six Contemporaries from Berlin*

1988
Amsterdam, Stedelijk Museum, and Institut Néerlandais, Paris, *Concept et Imagination*
Berlin, Neuer Berliner Kunstverein, *Zwischen Schwarz und Weiß*
Cologne, Kölnisches Stadtmuseum, *Augen-Blicke* (Traveled to Munich, Villa Stuck; Osnabrück, Kulturhistorisches Museum; Utrecht, Hedendaagse kunst.)
Freiburg, Triennale Internationale de la Photographie, and Musée d'Art Moderne de la Ville de Paris, *Splendeurs et Misères du Corps*
Paris, Musée d'Art Moderne de la Ville de Paris, *L'Imagerie de Michel Tournier*
Paris, Mairie de Paris, Paris Audiovisuel, *Aspects d'une Collection*
Rennes, Triangle Centre Culturel, *Une Douce Inquiétude*

1989
Berlin, Nationalgalerie, and Gulbenkian Foundation, Lisbon, *Von 1900 bis heute*
Rennes, Le Fonds Régional d'Art Contemporain, *La Lumière du Temps*
Dortmund, Museum für Kunst und Kulturgeschichte der Stadt Dortmund, *Inszenierte Wirklichkeit Fokus '89*
London, The Victoria & Albert Museum, *Photography Now*
Minneapolis, Walker Art Center, *Vanishing Presence* (Traveled to Winnipeg Art Gallery, Winnipeg; The Detroit Institute of Arts, Detroit; High Museum of Art, Atlanta; Herbert F. Johnson Museum of Art, Ithaca; and the Virginia Museum of Fine Arts, Richmond)

Paris, Musée National d'Art Moderne, Centre Georges
 Pompidou, *Donations Daniel Cordier: Le regard d'un
 amateur*
Pontault-Combault, Centre Photographique d'Ile de
 France, *Effets de Miroir*
Strasbourg, Collection du Musée d'Art Moderne et
 Contemporain, *Photographie*

1990
Berlin, Martin-Gropius-Bau, *Gegenwart-Ewigkeit: Spuren
 des Transzendenten in der Kunst unserer Zeit*
Budapest, Kunsthalle
Cologne, Galerie Rudolf Kicken
Limoges, Le Fonds Régional d'Art Contemporain,
 Première Epoque
Marseille, Biennale International de Marseille
Riga / Saint Petersburg, *Interferenzen: Kunst aus West-Berlin
 1960 – 1990*
Venice, La Biennale di Venezia, *Ambiente Berlin: XLIV
 Esposizione Internazionale d'Arte*

1991
Berlin, Galerie Springer, and Galerie Springer &
 Winckler, Frankfurt
Berlin, Orangerie, Schloß Charlottenburg, *Schwerelos*
Cologne, Galerie Rudolf Kicken, *Der fotografierte Schatten*
Essen, Museum Folkwang, Sammlung Manfred Heiting,
 Menschen

1992
Arles, Rencontres Internationales de la Photographie,
 Les Europeènes
Berlin, Berlinische Galerie, Museum für Moderne Kunst,
 Photographie, und Architektur, *Sprung in die Zeit*
Cincinnati, The Contemporary Arts Center, *The Self
 Revealed: Selections from the Collection of Kimberly
 Klosterman and Michael Lowe*
New York, Hirschl & Adler Gallery, *Portraits*
New York, The Museum of Modern Art, *New Photography 8*
Nice, Musée d'Art Moderne et Contemporain, *Le Portrait
 dans l'Art Contemporain*
Paris, Galerie Bouqueret et Lebon
Vienna, Wiener Secession, *Skulpturen-Fragmente*
Washington, D.C., The Corcoran Gallery of Art,
 Interface: Berlin Art in the Nineties

1993
Frankfurt, Frankfurter Kunstverein, *Das Bild des Körpers*
Freiburg, Elisabeth-Schneider-Stiftung
Munich, Bayerische Gemäldesammlung, Neue
 Pinakothek, *Industriefotografie heute*

1994
Berlin, Kunstbibliothek, *Zur Geschichte der Kunstbibliothek
 und ihrer Sammlungen*

Selected Bibliography

Monographs

Berlin, Galerie Georg Nothelfer. *Dieter Appelt: Die Symmetrie des Schädels*. Text by Walter Aue. Berlin, 1977.

Berlin, Galerie Springer, and Galerie Baudouin Lebon, Paris. *Dieter Appelt: Das Feld*. Text by Karlheinz Lüdeking. Berlin, 1991.

Berlin, Galerie Springer. *Appelt: Tableau Oppedette*. Text by Günther Gercken. Berlin, 1981.

Berlin, Galerie Springer. *Bethanien 2*. Text by Friedrich Teja Bach. Berlin, 1984.

Berlin, Galerie Springer. *Bethanien*. Text by Ursula Frohne. Berlin, 1991.

Berlin, Galerie Springer. *Sorano 1*. Text by Günther Gercken. Berlin, 1983.

Berlin, Künstlerhaus Bethanien. *Dieter Appelt: Museum der Sprachen*. Berlin, 1984.

Berlin, Neuer Berliner Kunstverein. *Dieter Appelt: Photosequenzen, Performance, Objekte, Filme*. Berlin, 1981.

Berlin, Nicolaische Verlagsbuchhandlung. *Appelt: Erinnerungsspur: Statische Vibration*. Text by Eberhard Roters. Berlin, 1979.

Berlin, Siemens Kulturprogramm. *Fotoprojekt 17*. Text by Bernd Weyergraf. Berlin, 1992.

Berlin, Verlag Dirk Nishen. *Dieter Appelt: Photographie*. Text by Bernd Weyergraf. Berlin, 1989.

Bordeaux, Galerie Arpa. *Dieter Appelt*. Text by Claude Pitot. Bordeaux, 1982.

Düsseldorf, Edition Marzona. *Appelt: Der Augenturm*. Düsseldorf, 1977.

Düsseldorf, Edition Marzona. *Appelt: Monte Isola*. Text by Walter Aue. Düsseldorf, 1976.

Düsseldorf, Edition Marzona. *Appelt: Selbstportraits 1975*. Düsseldorf, 1975.

Frankfurt, Springer & Winckler Galerie. *Dieter Appelt: Die Schatten erinnern an nichts*. Text by Bernd Weyergraf. Frankfurt, 1991.

Freiburg, Galerie Limmer. *Dieter Appelt: Tableaux*. Text by Ursula Frohne. Freiburg, 1992.

Liège, Musée d'Art Moderne. *Dieter Appelt: Photographies*. Liège, 1987.

Munich, Galerie Hermeyer. *Dieter Appelt: Die Präsenz der Dinge in der Zeit*. Text by Inken Nowald. Munich, 1985.

Munich, Galerie Hermeyer. *Dieter Appelt: Uranus*. Text by Janos Frecot. Munich, 1991.

Munich, Städtische Galerie im Lenbachhaus. *Dieter Appelt: Pitigliano 1982*. Texts by Helmut Friedel and Günther Gercken. Berlin, 1983.

New York, Sander Gallery. *Dieter Appelt*. New York, 1994.

Paris, Centre National de la Photographie. *Dieter Appelt*. Text by Michel Frizot. Paris, 1992.

Tournier, Michel. *Morts et Resurrection de Dieter Appelt*. Paris: Herscher, 1981.

Articles, Reviews, and Other Publications

"Allemagne Années 80." *Rencontres Art & Cinema* (1983).

Appelt, Dieter. "The Presence of Things in Time." *European Photography*, no. 27 (July–September 1986), pp. 16–19.

Berlin, Akademie der Künste. *Waldungen: Die Deutschen und ihr Wald*. Text by Bernd Weyergraf. Berlin, 1987.

Berlin, Berlinische Galerie, Museum für Moderne Kunst, Photographie und Architektur. *Sprung in die Zeit: Bewegung und Zeit als Gestaltungsprinzipien in der Photographie von den Anfängen bis zur Gegenwart*. Text by Hubertus von Amelunxen. Berlin: Ars Nicolai, 1992.

Berlin, Künstlerhaus Bethanien. *Performance: Eine andere Dimension*. Berlin: Frölich & Kaufmann, 1981.

Berlin, Nationalgalerie, and Neuer Berliner Kunstverein. *Kunstübermittlungsformen: Vom Tafelbild bis zum Happening*. Berlin, 1977.

Berlin, Nationalgalerie. *Kunst in der Bundesrepublik Deutschland, 1945–1985*. Berlin, 1985.

Berlin, Neuer Berliner Kunstverein. *Androgyn*. Berlin: Dietrich Reimer Verlag, 1987.

Berlin, Neuer Berliner Kunstverein. *Elementarzeichen*. Text by Lucie Schauer and Regelindis Westphal. Berlin: Frölich & Kaufmann, 1985.

Berlin, Neuer Berliner Kunstverein. *Zwischen Schwarz und Weiß*. Text by Wolfgang Max Faust. Exhibition curated by Dieter Appelt. Berlin, 1988.

Bruchholz, Ljudmila. "Sprung in die Zeit." *Kunst & Szene* 28 (December 1992).

Chevrier, Jean-François, et Jean Sagne. "L'Autoportrait Comme Mise en Scène: Essai sur l'Identité, l'Exotisme, et les Excès Photographiques." *Photographies* 4 (1984), pp. 47–82.

Cologne, Dumont Verlag. *Dumont Photo 2*. Cologne, 1980.

Cologne, Joseph-Haubrich Kunsthalle, and Neuer Berliner Kunstverein, Berlin. *Zehn:Zehn*. Text by Lucie Schauer. Berlin, 1987.

Creatis: Fine Photography 16 (1981), pp. 2–17, 23–27.

Dortmund, Museum für Kunst und Kulturgeschichte der Stadt Dortmund. *Inszenierte Wirklichkeit, Fokus '89*. Dortmund, 1989.

Ducros, Françoise. "Dieter Appelt and the Proof of Transparency." *Art Press* 111 (February 1987), pp. 12–15.

"Enrichissements: Bibliothèque Nationale, Paris." *Photographies* 1 (1983), pp. 86–94.

"Enrichissements: Bibliothèque Nationale, Paris." *Photographies* 7 (1985), pp. 82–89.

Frankfurt, Frankfurter Kunstverein. *Das Bild des Körpers*. Frankfurt, 1993.

Freiburg, Triennale Internationale de la Photographie, and Mois de la Photo, Paris. *Splendeurs et Misères du Corps*. Freiburg, 1988.

Geneva, Musée Rath. *Aspect de l'Art d'Aujourd'hui*. Geneva, 1981.

Ghent, Museum van Hedendaagste Kunst. *OFF OFF Festival 86*. Ghent, 1986.

Hamburg, Hamburger Kunstverein. *Das veränderte Selbstverständnis von Künstlern: Eremit? Forscher? Sozialarbeiter?* Hamburg, 1979.

Haworth-Booth, Mark. *Photography Now*. London: Dirk Nishen Publishing and the Victoria and Albert Museum, 1989.

Helsinki, Ateneumin Taidemuseo. *ARS 83*. Helsinki, 1983.

Houston, Benteler Galleries, Inc. *Photography Europe I*. Houston, 1981.

Lausanne, Musée Cantonal des Beaux-Arts. *Self-Portrait in the Age of Photography: Photographers Reflecting Their Own Image*. Lausanne, 1985.

Liège, Edition Yellow Now. *Relation et Relation*. Liège, 1978.

Lipovetsky, Gilles. "Cadavre Elementaire." *Silex* no. 4 (1978).

London, National Portrait Gallery. *Staging the Self: Self-Portrait Photography 1840–1980*. London, 1987.

Metz, Musée pour la Photographie. *Théâtre des Réalités*. Metz, 1986.

Morin, Didier. "En Carnac, ou les pierres animées," *Photographies* 8 (1985), pp. 13–15.

Nuridsany, Michel, ed. *Effets de Miroir*. Ivry-sur-Seine: Information Arts Plastiques Ile de France, 1989.

Nurisdany, Michel. "Les Ecrivains et la Photographie." *L'Express* 1468-1. Paris, 1979.

Ohff, Heinz. "Umfeld Bethanien." *Das Kunstwerk* 37 (April 1984), p. 71.

Paltzer, Rolf A. "An Ascetic takes the Stage." *Art: Das Kunstmagazin*, no. 7 (July 1986), pp. 70–77.

Paris, Centre National de la Photographie. *Le Nu*. Paris, 1986.

Paris, Editions du Centre Pompidou. *Autoportraits Photographiques 1898–1981*. Paris, 1981.

Paris, Editions du Centre Pompidou. *Donations Daniel Cordier: Le regard d'un amateur*. Paris, 1989.

Paris, Institut Néerlandais, and Stedelijk Museum, Amsterdam. *Concept et Imagination*. Paris, 1988.

Paris, Les Collections de la Bibliothèque Nationale, France. *15 Ans d'Enrichissement*. Text by Jean-Claude Lemagny. Paris, 1984.

Paris, Mairie de Paris, Paris Audiovisuel. *Aspects d'une Collection*. Paris, 1988.

Paris, Musée d'Art Moderne de la Ville de Paris. *L'Imagerie de Michel Tournier*. Paris, 1988.

Poinsot, Jean-Marc. *20th Century Art and Megaliths*. Rennes: University of Rennes, 1986.

Porto, Casa de Serralves. *Foto Porto*. Porto, 1988.

Rennes, Le Fonds Regional d'Art Contemporain. *La Lumière du Temps*. Rennes, 1989.

Rimbaud, Arthur. *Das trunkene Schiff* and *Eine Zeit in der Hölle*. 2 vols. Munich: Verlag Matthes & Seitz, 1979–80.

Roegiers, Patrich. "Question de Vie et de Mort," *Cliché*. Brussels, 1982.

Roodenburg, Linda. "Dieter Appelt: Die Präsenz der Dinge in der Zeit." *Perspektief* 34 (December 1988), pp. 32–41.

Sauerbier, S.D. "Die Schatten Lichtbilder," *Eikon I* (1991).

Schmid, Joachim. "The Photographic Process." *European Photography*, no. 30 (April–June 1987), pp. 13–55.

Schmied, Wieland. *Gegenwart-Ewigkeit: Spuren des Transzendenten in der Kunst unserer Zeit*. Stuttgart: Cantz, 1990.

Stockholm, Kulturhuset. *Käusla och Hardhet*. Stockholm, 1982.

Tokyo, Hara Museum of Contemporary Art. *Six Contemporaries from Berlin*. Tokyo, 1987.

Tournier, Michel. *Des Clefs des Serrures*. Paris: Chène/Hachette, 1979.

Venice, La Biennale di Venezia. *Ambiente Berlin: XLIV Esposizione Internazionale d'Arte*. Milan: Gruppo Editoriale Fabbri, 1990.

Vielhaber, Christiane. *Augen-Blicke*. Cologne: Vista Point Verlag, 1988.

Vienna, Wiener Sezession. *Skulpturen, Fragmente: Internationale Fotoarbeiten der 90er Jahre*. Text by Jonathan Crary and Herta Wolf. Zurich: Parkett Verlag, 1992.

Washington, D.C. The Corcoran Gallery of Art. *Interface: Berlin Art in the Nineties*. Washington, D.C., 1992.

Weinberg, Adam. *Vanishing Presence*. Text by Adam Weinberg, Eugenia Parry Janis, and Max Kozloff. Minneapolis: Walker Art Center, and New York: Rizzoli International, 1989.

Weski, Thomas, ed. *Siemens Fotoprojekt 1987–1992*. Berlin: Ernst & Sohn, and Munich: Siemens Kulturprogramm, 1993.

Weyergraf, Bernd. "Dieter Appelt." *European Photography*, no. 53 (Spring 1993), pp. 23–29.

Wiegand, Wilfried. "The Metaphysicians of Dionysus: Comments on the New German Photoworks." *Aperture* 123 (Spring 1991), pp. 70–85.

Index